BELONGING AND GLOBALISATION

Emily Jacir, 2005
Embrace
Rubber, aluminium, motor and motion sensors
49.5 cm x 179 cm diameter
Courtesy Alexander and Bonin, NYC

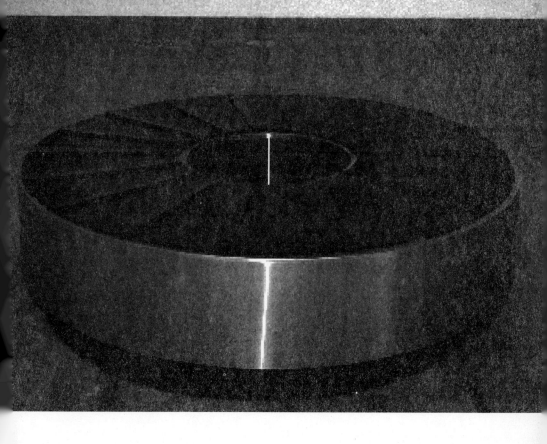

BELONGING
AND
GLOBALISATION

Critical Essays in
Contemporary Art and Culture

Edited by
Kamal Boullata

SAQI
London San Francisco Beirut

ISBN: 978-0-86356-666-0

Manufactured in Lebanon

SAQI
26 Westbourne Grove, London W2 5RH
825 Page Street, Suite 203, Berkeley, California 94710
Tabet Building, Mneimneh Street, Hamra, Beirut
www.saqibooks.com

Contents

Foreword

All essays included in this volume have originally appeared in the catalogue of the 7th International Biennial of Sharjah held from 6 April to 6 June 2005 at the Sharjah Art Museum and the Expo Centre in Sharjah, the United Arab Emirates. As editor of the exhibition's catalogue, I had invited a number of international experts from different fields including art history, sociology, art and cultural criticism to contribute essays on the state of contemporary art and culture from their own perspectives with a special focus on 'belonging', the theme of that year's biennial.

The invited essays appearing here in the first section, 'Critical Perspectives', were all written before the biennial's opening. Members of the curatorial team wrote their texts during the preparatory period of mounting the event. These writings appear in the second section, entitled 'The Sharjah Experiment'. The text by Head Curator Jack Persekian is the only contribution that has been updated for this publication with the intention to bring in a retrospective reflection on the exhibition.

As one of the youngest biennials to emerge from the mounting number taking place worldwide, the 7th Sharjah Biennial marked a turning point in its brief history. It was distinguished for being a unique experimental site where a significant number of artists created site-specific installations that engaged the participation of a public that is mostly unfamiliar with the grounds of contemporary art. With a focus on the subject of 'belonging', this volume brings together the reflections of critics and curators to explore how art produced today outside the bounds of mainstream cultural circuits is responding to the challenges posed by the central forces of globalisation.

While the nature of exhibitions, regardless of their importance, is always

transient, texts written on their occasion are usually what remain to learn from and build upon.

As the issues addressed in the writings appearing in the 2005 catalogue continue to be relevant and their subject has never ceased to fuel debates in today's discussions, it was deemed necessary to bring out these texts in book form that they may reach an audience beyond the one that had the opportunity to view the Sharjah Biennial.

Over the last two years, friends who had no access to the Biennial's catalogue continued to express interest in seeing its critical writings gathered in a book. None was more vehement in his pursuit than my Jerusalem boyhood friend Farid Ohan, Director of the Sharjah Higher Colleges of Technology. To him I owe special thanks. My deepest gratitude goes to Mai Ghoussoub, co-founder of Saqi Books. Being an artist, writer and publisher, she was quick to detect the necessity of bringing this work to light. Her untimely death has left everyone who has ever known her shocked and bereft. Thanks to her colleague André Gaspard, and to all members of the staff at Saqi Books, particularly Lara Frankena, who lost no time in completing the publication of this book on schedule the way Mai would have liked it to be. By continuing to bring out the kind of books that she believed in, Mai's memory shall live on.

K. B.

Menton, France, February 2007

Sharing a Meaning: An Introduction

Kamal Boullata

When I invited contributors to write on the subject of 'belonging' for the catalogue of the 7th Sharjah Biennial, and whose writings now appear in this volume, I could not imagine including contributions from curators and art and cultural critics from different parts of the world without including one from an Arab poet. In that part of the world, the poet's voice has never ceased to personify all the different connotations of belonging. Since pre-Islamic times, when poetry was the desert nomad's only portable tool of self-expression, and well after urban centres were established across the Mediterranean, stretching from Damascus to Baghdad and from Cairo to Cordova, poetry has continued to be treasured as *Diwan al-'Arab,* meaning the Arabs' chief register of their collective memory.

Today, when the metropolitan centres of our planet are bursting with urban nomads of every race and where feeling 'at home' is no longer confined to a place of origin, collective memory has been insulated in traditional as well as modern societies by an emerging tribalism that is firing back at the lightning changes of our globalising world. In such a world where premodern affiliations and the postmodern pace of frantic developments coexist, the subject of belonging raises a whole new set of questions for poets and artists everywhere to ponder. Local and international artists participating in the Sharjah Biennial were invited to explore the issue of belonging through their art, and contributors to this volume offer diverse ways of approaching the subject. Their different points of view make it possible for us to 'go back and forth between local and global perspectives, in the same way as our vision constantly moves back and forth between

the near and far'.[1] Before plunging into the essays, however, the reader may benefit from reflecting on two words that recur throughout most of these contributions; they are *belonging* and *globalisation*. By contrasting the English and the Arabic words used for 'belonging' a new perspective is gained that allows a broader apprehension for 'globalisation', a word that has aroused profound and impassioned debates around the world since the 1990s.

In pursuit of a better understanding of how 'belonging' relates to what Frederick Bohrer calls 'the globalised, fractured, and transnational world of our time', Bohrer suggests a 'rethinking [of] the idea of "belonging" and reconnecting it with its linguistic roots'. Surprisingly, the origins of the English and Arabic terms differ drastically from the one we associate with them today in each of the two languages. What is most interesting is the way that the original meaning of 'belonging' in one language crosses over into the other language as the word evolved into its usage today.

Bohrer informs us that before the English word 'belonging' implied 'possession', or 'some form of ownership', it originally meant 'a much looser sense of correspondence ... between two things' that may be 'equally long, corresponding in length, running alongside of, parallel to, going along with'. He goes on to explain that 'belonging is not in any sense about being necessarily in the same place but rather about two things sharing something significant, wherever they are located' and that '"belonging" only becomes evident through some degree of distance, that the two require each other'. Thus, we conclude that the English word originally had *spatial* implications.

In contrast, the Arabic word *intima'* meaning 'belonging' derives from the triliteral root *nmw*, which means 'grow, thrive, prosper, augment, multiply, flourish and make progress'. Its other triliteral root form, *nmy*, refers specifically to development and increase in material terms.[2] The derivative word *tanmiya* means 'development' and *namiya* is 'developing' as in the term *developing nations*. Thus, unlike the English origin that implies spatial connotations, all meanings of the Arabic origin imply an activity that

1. Patrice C. Brodeur, 'From postmodernism to "glocalism": towards a theoretical understanding of contemporary Muslim constructions of religious others', in Birgit Schaebler and Leif Stenberg, eds, *Globalization and the Muslim World: Culture, Religion and Modernity* (New York, Syracuse University Press, 2004), p. 192.

2. Hans Wehr, *A Dictionary of Modern Written Arabic*, 3rd edn, ed. J. Milton Cowan (Ithaca, New York, Spoken Languages Services, 1976), p. 1001. See also Butros al-Bustani, *Muhit al-Muhit* (Beirut, Maktabat Lubnan, 1977), p. 918.

unfolds over time. And yet, each of the meanings of the Arabic origin seems curiously to correspond to the meaning of the word as it evolved in English. Thus, the meanings implying 'growth' and 'prosperity' in the Arabic root go hand in hand with the evolved meaning of 'ownership' and 'possession' in English. Similarly, the English origin of the word that implies space between two entities at a distance from each other seems to describe the way the word 'belonging' evolved in Arabic expression.

In their discussion of contemporary art or what Arthur Danto calls 'posthistorical art', both Jean Fisher and Laymert dos Santos raise some fundamental questions about the concept of belonging. Fisher reminds us that in English 'belongings' refer to 'private property'; she asks 'how far the meaning of 'belonging' as "possession", "property", or "attribute" ... is still limited by the horizon of Cartesian subjectivism, whose legacy is the sacrifice of community and solidarity to an acquisitive, self-interested individualism'. Dos Santos goes further to explore the terrible ramifications of the question, 'who has the right to belong to the future of humanity, and who is condemned to disappear?'

Whereas Fisher and dos Santos as well as the other contributors present different perspectives on how 'belonging' and the right 'not to belong' may be read through today's art, it is important to keep in mind how on another level the English word 'belonging' has come to have a 'shared meaning', to borrow a Stuart Hall term, in its spatial connotations with the language that first saw the light among Arabia's nomads. Of course, it is in the field of Arabic poetry that 'belonging' found its earliest and most eloquent expression.

For the roaming nomads who belonged to the language of their ancestors more than they could ever belong to any definable piece of territory, poetry was the mirror of their collective identity and memory, their compass for measuring the distance between one abode and another. Unceasing movement between one place and another as between a past experience and a present one punctuated pre-Islamic poetry. To *be* in and to *long* for were intimately associated with each other, and their association became the poetry's major hallmark, affirming collective identity and all the connotations of belonging. Traces of the abandoned campsite of the beloved marking the distance between lovers introduced all odes remembered from this pagan and pristine period. When al-Farahidi, the eighth-century founder of Arabic prosody, wrote that poets 'make what is near distant and what is distant near',

as Elias Khoury reminds us in his essay in this volume, pre-Islamic poetry was the model for his classicism. Al-Farahidi, however, could not have predicted that the spatial connotation inherent in his poetic prototype was destined to become a dominant feature in Arabic poetics long after the Arabs had left their desert campsites behind to establish luxurious urban centres and fabled gardens across their territorial realm.

At the zenith of the Umayyad period, for example, a poet who was the wife of the caliph in Damascus expressed her sense of belonging by dismissing the 'lofty palace' she lived in because her heart longed for a home 'in a tent lashed by the winds'. Centuries later a poet in Cordova expressed his experience of belonging by addressing a palm tree he planted in his private orchard 'far from the land of palms'; he wrote, 'you have sprung from soil in which you are a stranger/And I, like you, am far from home'. And when feeling at home was experienced throughout the known world in which Arabic had become the lingua franca, it was the Sufi poets who, by pointing to a place beyond the comforts of this world, perpetuated the tradition of longing for a distant home.

Thus, affirming one's *be/*ing through *longing* was to become a touchstone of aesthetic expression throughout Arab culture. In its development over the centuries, this trait overshadowed all the oral arts that were imbued by the same aesthetic sensibility, spreading even to medieval Romance and troubadour minstrels. Long after the Arabs left al-Andalus, the name they gave to the Iberian Peninsula, traces of longing mixed with lamentation of what has always seemed to be an irretrievable loss continued to express the performer's state of *be/*ing. Today, this quality is especially evident in the improvisational singing tradition of the Spanish flamenco and the Portuguese fado in which there is hardly any song that does not include the word *saudade,* which denotes different states of longing. The unique quality such vocal music evokes, which Lorca described as 'dark sounds' (*sonidos negros*), had the kind of hypnotic spell that has been magnificently perpetuated in the Arab musical tradition by the Egyptian Um Kalthum.

After the Palestine débâcle, Arabic poetry found its quintessential voice in articulating the sense of *be/longing* of a people who were exiled and dispossessed. Measuring the distance between home and exile was no longer confined to looking back and longing for a paradise lost. This time, deracinated poets and artists pointed to the distant horizon of a wilderness

in which their people were being banished. 'Where should we go after the last frontiers?' asked Mahmud Darwish. 'Where should the birds fly after the last sky?' In the visual arts, Mona Hatoum's video work *Measures of Distance* encapsulated in a matter of fifteen minutes the artist's personalised experience of *be/longing* and the ethos of a whole oral tradition that was first formed among the desert nomads.

In contrast with the word 'belonging', which crossed over from English to describe the spatial associations of Arab culture, the word *globalisation*, which was coined at the close of the second millennium, continues to be an ambiguous and a contested neologism in both English and Arabic. To introduce it, Frederic Jameson used the metaphor of the proverbial elephant described by its blind observers in so many different ways. Yet one can assume the elephant's existence even though there does not appear to be any precise or persuasive definition for it.[1]

As it is generally understood today, globalisation is a postindustrial capitalist phenomenon with far-reaching implications for the world in the political, economic and cultural spheres. It is often thought to be an unprecedented phenomenon in world history. Yet some forms of globalisation have always been with us, long before the computer and the Internet.[2] However, the significant difference between earlier forms of globalisation and its current manifestations may be summed up in the way our age prioritises time over space. With our ever-expanding communication networks, transnational trade, and interchanges in all fields and at all levels over great distances and at ever-greater speed, those who view the history of the West as a universal world history do not stop to reflect on how the earlier forms of globalisation actually preceded the printing press and even the discovery of the New World.

Among the many past examples of globalisation, one may mention

1. Frederic Jameson and Masao Miyoshi, eds, *The Culture of Globalization* (Durham, Duke University Press, 1999), p. ix.
2. Janet L. Abu Lughod, *Before European Hegemony: The World System AD 1250-1350* (New York, Oxford University Press, 1989). See also A.G. Hopkins, ed., *Globalisation in World History* (New York, W.W. Norton & Co., 2004).

the Hellenistic and Roman eras. But in this context, we pick an example from Arab cultural history, specifically the case of al-Andalus. If we were to consider some of the cultural manifestations of today's globalisation such as the mobility of people, the wide web of routes that link the world together, pluralism, multi-ethnic relations, hybridisation and accessibility of knowledge, we would understand why al-Andalus was considered to be the centre of the civilised world in medieval Europe.

For seven centuries or more (over three times the entire history of the United States of America), al-Andalus represented the golden age par excellence for different communities that shared a creative life together. Thanks to the interfaith relations that were sustained under Islam, Jews, Christian and Muslim communities flourished side by side and their religious differences did not hinder their search for the truth in religious, scientific or philosophical matters. The major ethnic groups of Arabs, Berbers and indigenous Spaniards blended together using at least five languages. Muslims, Christians and Jews spoke two of them, Andalusian Arabic and the Romance dialect that later evolved into Spanish. Besides classical Arabic, written languages included Latin and Hebrew.[1] As Arabic was replacing Latin as the language of science and art, Hebrew (until now used only for liturgical purposes) was for the first time used to communicate secular matters. Many of the new findings recorded in Arabic combined Greek scientific knowledge with those of Iran and India.

Although this state of affairs was periodically marred by invading Berber tribes whose single-mindedness and narrow interpretation of Islam did not tolerate the pluralism and openness that came with learning, wealth and scientific progress, al-Andalus carried on the interfaith tradition between Muslims and Catholic Christians that their Umayyad forebears had established in the East with the Orthodox Christians. In this atmosphere of mutual tolerance, luminaries such as Ibn Rushd (Averroes), a Muslim, and Ibn Maimun (Maimonides), a Jew, wrote their philosophical treatises in Arabic as Abelard, a Christian, continued to be read in Latin. In the meantime, the writings of someone like Ibn Arabi wielded influence on mystical thought not only in Islam in the West and the East but also in Christianity for centuries to come.

Al-Andalus was thus a beacon for all those who flocked there from every

1. Hourani, *A History of the Arab Peoples* (New York, Warner Books Edition, 1991), p. 194.

corner of Europe seeking enlightenment and eventual freedom from the Dark Ages they had been living in. In Cordova alone, which boasted many libraries, the caliph's contained 'some four hundred thousand volumes ... when the largest library in Christian Europe probably held no more than four hundred manuscripts'.[1] It is no wonder that Toledo eventually became the translation centre of Europe, and it was within the walls of its library that the spark of the Renaissance was first ignited. With the conquest of the Americas, the Iberian Peninsula that once marked the extreme end of the known world was overnight turned into the epicentre of the globe. In the meantime, the Renaissance began to unfold in Europe as the Hispanic colonisation of North and South America was under way. Scholars in the West often consider that that moment in history announced the beginning of the modern world.

The fine arts and crafts produced in al-Andalus represented the most elegant expression of medieval refinement and aesthetic sensibility. Insofar as hybridity influences much of contemporary art and architecture, hybridity had been the connective tissue that tied together Islamic art and architecture created in al-Andalus. Later art historians identified these styles with the Spanish renderings of the Arabic words that were associated with the different communities of the country. *Mudejar* (from the Arabic word *mudajjan,* literally meaning 'hybrid') referred to the Arabic-speaking Muslim who adopted the Christian faith and thus combined Muslim and Christian references in creating the art object. Likewise, *mozarab* (from the Arabic word *musta'rib* meaning 'Arabised') referred to the Christian living under Islam in al-Andalus who adopted the Arabic language and took part in Islamic culture.

Unlike our own era with its technological commodities that allow us to traverse boundless distances in 'real time', however, in the medieval world of al-Andalus time was a correlative of space. Cartography and navigation were highly developed throughout the history of al-Andalus; consequently, vigorous trading routes linked many regions of the known world. Owing to the fact that over the centuries, Islam covered regions that spread from the Mediterranean Sea to the Indian Ocean, it was possible for example for an Andalusian like the thirteenth-century traveller Ibn Battuta to reach Southern

1. Menocal, *The Ornament of the World: How Muslims, Jews and Christians Created a Culture of Tolerance in Medieval Spain* (Boston & New York, Little Brown & Co., 2002), p. 33.

Russia, India and the Maldive Islands from Morocco and return home to
report the discussions he had had with men of learning he had encountered
on his way. That sort of communication was of course possible because of
what Albert Hourani called the 'link of a common culture expressed in the
Arabic language' throughout the countries Ibn Battuta explored.[1] No wonder
that when Christopher Columbus set sail to what he thought would be the
Indies, he took with him Luis de Torres, an interpreter who spoke Arabic.
Thus, in the first encounter between a European and a Native American, the
first words addressed to the natives were voiced in Arabic.[2]

Today the effects of that era can still be detected through living languages
in Asia and Europe where words originally borrowed from Arabic have been
fully integrated and their origin forgotten. Similarly, the effects of medieval
globalisation may also be discerned in visual expression whereby echoes of
arabesque patterns refined in al-Andalus have travelled to lands bordering
on China in the Far East; in the far West, these same Andalusian arabesques
continue to mark the decorative arts of Latin America.

<p style="text-align:center">***</p>

Although today's globalisation may continue to be an indefinable neologism,
one may learn something about it by examining the fields that fall under
its spell. Essays in this volume do this by showing how different today's
globalisation is from yesterday's and how this difference leaves its mark on
art and on today's experience of cultural identity and 'belonging'.

Achille Bonito Oliva, who was the chief curator of the 1993 Venice
Biennial and one of the earliest art critics in Europe to discuss the effect
of globalisation on art, offers an explanation in the context of the Sharjah
Biennial's theme of belonging. He writes, today's 'globalisation threatens
identity in that it eliminates any attempt at personalising one's existence.
The counteraction is *tribalisation,* a frequently reactionary and regressive
response.' He points out that in such a world artists

 produce their own imagery saved from the two extremes of

1. Hourani, *History of the Arab Peoples*, p. 129.
2. Menocal, *Ornament of the World*, pp. 250–1.

globalisation and *tribalisation*. They adopt a tactic marked by cultural nomadism to escape the perverse consequence of tribal identity and, at the same time, claim the creation of what is symbol against the commoditisation of global economy. Thus, artists exercise their right to diaspora, their freedom to wander across the boundaries of various cultures, nations and media forms. So, they refuse the idea of belonging and choose to deny the value of space ... in favour of the value of time condensed in the form of their work.

Similarly, when Nicolas Bourriaud considers the issue of 'belonging' he writes, 'artistic activity does not involve obeying a tradition or belonging to a cultural community, but rather learning to detach oneself, at will, to reveal something that has never been displayed.' Like Achille Bonito Oliva, Bourriaud stresses the role played by global economics on art. 'Contemporary art', he writes, 'is above all contemporary with the economy that envelops it.' Today's artists, he concludes, do not so much reflect 'their culture as the mode of production of the economic ... spheres within which they operate'.

'What is there to be sold?' asks Boris Brollo as he considers artists' current works that include happenings, performances, photographs, videos and installations. He retorts, 'it is not the art work as such, but the emotion evoked by the work itself' that counts. By nurturing 'aesthetic emotion', he says, we can all begin to look at a work of art 'without feeling a need to possess it'. That way of looking, to him, represents what has all along been the 'classical root of contemporary art'.

Gerardo Mosquera discusses international perspectives on art and culture in our globalised world – albeit a world with centres (of power and wealth) and peripheries. He asserts that 'signs of change' in contemporary art are no more discerned in the traditional centres of art and culture but rather in the 'peripheries'. This is so, he says 'because of their location on the maps of economic, political, cultural and symbolic power'. The peripheries, he points out, 'have developed a culture of *resignification* out of the repertoires imposed by the centres.'

'Everything is hiatus', writes Nadia Tazi. In addressing herself to what she calls 'the complexity of the globalising world' and how all sense of 'belonging' may be 'suspended in an elsewhere that is nowhere', she takes up the site of the Straits of Gibraltar, which brings Africa and Europe within viewing distance of each other. Tangiers, from which the twenty-one-year-

old Ibn Battuta once sailed out to explore the globalised world of his time, is in our globalised world 'becoming known for its slums'. Its youth 'living in the suspension between two worlds' risk their lives at sea just to cross over to Europe. The ritual of burning all their identity documents *before* embarking on the clandestine sea journey recalls how the troops that in the eighth century conquered the Iberian Peninsula had been ordered to burn their ships *after* they set foot at Gibraltar, the mountain that still bears the name of their military commander Tareq Ibn Ziyad (*Jabal Tareq* – Gibraltar). In her essay discussing the images of a young Moroccan photographer, Tazi's words describe her own way of *resignification*, which 'open[s] up space of overlapping questions, linked to the boundaries in the logic of time and space, about the relationship between politics and aesthetics, about social and cultural distances'.

Edward Said, whose writings on the relationship between politics and aesthetics have been seminal in postcolonial studies, is here discussed by Joseph Massad. How did this fearless and impassioned advocate of the Palestinian cause in the West maintain his stern 'resistance to nationalist belongings', as Massad writes? Was Said's resistance the result of speaking from the privileged position of an academic, as some nationalists back home have claimed? How did the author of *Out of Place*, a memoir of his formative years, voice his own sense of belonging? Having written extensively on how politics and aesthetics relate in both literature and music, how did Said relate to the visual? Massad's essay attempts to answer all these questions in a language that is no less lucid than that of Said. Most importantly, it shows how, unlike many contemporary critics whose discourses exalt 'the embedding of literature in language ... in which language *produces* (rather than is produced by) meaning', Said's discourse always positioned the 'dialectical actualities of human reality' at the centre of his discourse.[1]

Jean Fisher writes that 'there is no meaning if meaning is not shared'. The poem introducing the essays in this volume by the Libyan Khaled Mattawa 'holds on to [his] own story [and] "singularity"' to use Fisher's expression. Through it, a legendary history that the poet embraces unfolds upon his encounter *with* another human being. It is this 'with' that according to Fisher 'is constitutive of Being'. Here, in his attempt to sum up his sense of *be*-ing

1. Edward W. Said, *Power, Politics and Culture: Interviews with Edward W. Said*, ed. Gauri Viswanathan (London, Bloomsbury Publishing, 2004), p. 7.

and be-*longing*, the poet asks: 'Is that my face I see /reflected in your eyes?' Fisher concludes: 'art's origin and destiny no longer lie in the movement from and to an autonomous self, but in sustaining a poetic imagination capable of disclosing the ethos or common dwelling place of our humanity.'

Critical Perspectives

History of My Face

Khaled Mattawa

My lips came with a caravan of slaves
That belonged to the Grand Sanussi.
In Al-Jaghbub he freed them.
They still live in the poor section of Benghazi
Near the hospital where I was born.
They never meant to settle
In Tokara those Greeks
Whose eyebrows I wear
– then they smelled the wild sage
And declared my country their birthplace.
The Knights of St John invaded Tripoli.
The residents of the city
Sought help from Istanbul. In 1531
The Turks brought along my nose.
My hair stretches back
To a concubine of Septimus Severus.
She made his breakfast,
Bore four of his sons.
Uqba took my city
In the name of God.
We sit by his grave
And I sing to you:
 Sweet lashes, arrow-sharp,

Is that my face I see
Reflected in your eyes?[1]

1. The poem appeared in *Ismailia Eclipse*, Dartmouth, NE: Sheep Meadow Press, 1995.

Borders (and Boarders) of Art:
Notes from a Foreign Land

Frederick N. Bohrer

'I'm a smuggler in borders.'

'And what do you smuggle?'

'Didn't I just tell you? Borders: landmarks, barriers, stone markers, barbed wire, dotted lines.'[1]

The theme of the Sharjah 7 exhibit is 'belonging'. Its programme statement focuses on art that works to 'challenge our inherited assumptions about home, identity, and belonging'. What does belonging mean today? These things, we say, belong to me, or us, or our culture. We say something similar about people as well. Indeed, to say or be told that you belong with someone can be one of the most moving statements of one's life. The stakes in belonging, then, are pretty high. Does not everyone want somehow to belong? Belonging in this sense involves issues of community, of interpersonal social/cultural/political/erotic connections, and indeed the entire complex of ways that people and objects class and associate themselves – the full spectrum of ways that we decide what and who goes along with what and whom.

Common as this conception is, that is not all belonging has meant or could mean. I wonder if the strange geopolitical realities still emerging in the globalised, fractured and transnational world of our time might not benefit from rethinking the idea of belonging and reconnecting it with its linguistic roots. In fact, the meaning of belonging most common today, derived from

1. From Toilet Pereyra, an Argentinian comic strip. Quoted in Néstor Garcia Canclini, *Hybrid Cultures: Strategies for Entering and Leaving Modernity* (Minneapolis, University of Minnesota Press, 1995), p. 255.

the traffic in objects and often implying some sort of ownership, is a very recent one. It is a kind of belonging that one might well expect to find in a materialistic world. Belonging itself, though, is a much older and more venerable concept.

The *Oxford English Dictionary* describes what was meant by 'belonging' as it was first used nearly 1,000 years ago; it referred both to a condition and to a class of things. 'The [word's] primary notion', we learn, 'was apparently "equally long, corresponding in length" whence "running alongside of, parallel to, going along with, accompanying as a property or attribute"'.[1] What is historically fundamental about belonging, then, is not any formal attachment or connection, but rather a much looser sense of correspondence or association between two things or parties. Belonging is not in any sense about being necessarily in the same place but rather about two things sharing something significant, wherever they are located. More important, the idea of belonging as ownership, so significant now in the modern West, has almost nothing to do with this earlier account and is barely mentioned in the dictionary's description. An old saying has it that 'we are possessed by our possessions'. Accordingly, it seems that an overwhelming concern with possessions and possessing may have foreclosed on the viability of other, non-possessive, conceptions of belonging.

What else, then, could be meant by belonging? What significance might it have in art or elsewhere? First, it is evident that to belong was never so much to be *in* as to be *of* a place. Just as being equally long, in the dictionary definition, is precisely what in mathematics is called *identity*, so too belonging is fundamentally a question of identity. The equal length of two lines remains equal no matter how far away from each other they are located. One might go even further to say that belonging only becomes evident through some degree of distance, that the two require each other. Two equal lines, after all, must be pulled apart to be compared. While cultural identity is vastly more complicated to measure, it too can be manifest through comparison at a distance.

But important as it is to belong, group identity must be seen in counterpoint to individual identity. Surely this is especially important to an artist, or anyone who wants their work to be seen as her or his own, and

1. *The Compact Edition of the Oxford English Dictionary* (Oxford, Oxford University Press, 1971), 2 vols, I, 198, 'Belong'.

not merely as the product of a collective force. Belonging, like anything else, is something from which the artist can make art. The linguistic, social and cultural practices of one's 'heritage' are not just a given; they are more like raw material, one of the many things that enter into one's art. Furthermore, as we come to see identity in the interplay of various dynamic forces, it follows that identity itself is not fixed, but fluid – not given, but performed.

In this context, Stuart Hall writes:

> Perhaps instead of thinking of identity as an already accomplished fact ... we should think, instead, of identity as a 'production' which is never complete, always in process, and always constituted within, not outside, representation.[1]

This is a key challenge of our time. Hall makes the case for understanding concepts like belonging and home in contexts of migration, statelessness, diaspora and similar features of a globalised world. Counterintuitive as it may seem, this conception is already with us, rooted in the trajectories of transnational life.

Five years ago I attended the press opening of an exhibit of some works by Jananne al-Ani, an artist born to an Iraqi father and Irish mother, who grew up in Iraq and now works in London. The works on display represented in different ways the artist, her mother and three sisters oscillating between two cultures: the women appear both in modern Western dress and veiled according to Islamic practice. It was both a poignant and somehow comic conjuring, as these women floated in a continuous interchange between two cultural conventions. One member of the press asked the artist if her work was a way of getting in touch with her cultural 'heritage'. A simple yes was probably what the man wanted, but the artist replied instead that she had no such intention, that identity was something more to be made and played out than recaptured. Indeed, the work pictured something never before seen, certainly not a past home but a present condition. In Hall's terms, we saw an identity constituted *within* representation. That is, it is a sense of oneself and others that emerges in the making, not one designed to correspond to some prior, exterior condition. It comes about not through reiterating but rather

1. Stuart Hall, 'Cultural identity and diaspora', in P. Williams and L. Chrisman, eds, *Colonial Discourse and Post-Colonial Theory: A Reader* (New York, Columbia University Press, 1994), p. 392.

questioning or recontextualising inherited cultural practices.

How does one live in such a world? This is surely a key question for our time and a driving force behind the emphasis on hybridity in postcolonial and cultural studies in recent decades. Edward Said wrote in 1993 that 'some notion of literature and indeed all culture as hybrid (in Homi Bhabha's complex sense of that word) and encumbered, and entangled or overlapping with what used to be regarded as extraneous elements – this strikes me as *the* essential idea for the revolutionary realities today'.[1] Hybridity may have become controversial since then, but it is a controversy unavoidable for the very reason stated by Said: the global intermingling of cultural elements.

The dust-up over hybridity is hardly worth recapitulating here; its stakes are more directly theoretical and critical. I want instead to focus on a lesser known point of Said, his own earlier response to cultural encumberment. Said (and before him Eric Auerbach) more than once quoted with approval a maxim of Hugo of St Victor, a medieval Christian mystic: 'The man who finds his homeland sweet is still a tender beginner; he to whom every soil is as his native one is already strong; but he is perfect to whom the entire world is as a foreign land.'[2] Said praised the 'generosity' of these lines, with their 'combination of intimacy and distance'. They present a worldliness that feels equally uncomfortable everywhere, one which makes any simple belonging (interestingly, artfully) problematic. For Hugo, the medieval spiritualist, the lines are meant to impress on neophytes that they ought never be overly involved in things of this world, because they belong ultimately to heaven and things beyond the material. But they are eminently appropriate today as they suggest a way of being in, and perhaps even having some faith about, this uncertain and divided age.

The entire world as a foreign land. This is surely a leitmotif of the writings of transnational artists. I have found it in many places but will let the words

1. Edward W. Said, *Culture and Imperialism* (New York, Vintage Books, 1993), p. 317. Italics in original. For Bhabha see especially Homi K. Bhabha, *The Location of Culture* (New York, Routledge, 1994). Among the many critiques and modifications of hybridity, see for instance Robert J. C. Young, *Colonial Desire: Hybridity in Theory, Race, and Culture* (New York, Routledge, 1995). A useful guide to postcolonial theory is Bart Moore-Gilbert, *Postcolonial Theory: Contexts, Practices, Politics* (London, Verso, 1997).
2. First cited, so far as I know, in Edward W. Said, *Orientalism* (New York, Vintage, 1979), p. 259. See Said's slightly later essay, 'Secular criticism', for a more extended treatment of this question, in *The World, the Text, and the Critic* (Cambridge, MA, Harvard University Press, 1983), pp. 1–30.

of Mona Hatoum stand for the group. Born in Lebanon, daughter of stateless Palestinian émigrés, she first settled, by necessity, in England in 1975, when the Beirut airport was shut down at the start of the Lebanese civil war. 'There's always the feeling of in-betweenness', she states, 'that comes from not being able to identify with my own culture or the one in which I'm living.'[1] This is a vision which seems much like Hugo's earth without its redemptive heaven. To look at it that way is to take seriously and on own terms the deep pain and suffering involved in the dislocations, diasporas and indeed holocausts of modern times. The works of artists such as Alfredo Jaar, Fazal Sheikh and William Kentridge, to name a few associated with various parts of the world, have been created in the process of facing up to such events.

But even to bring up the making of art in and from such conditions starts to shift the expectations involved. It makes evident that a fundamental possibility for redemptive meaning lies in the earth itself. In-betweenness, cultural encumbrance, fracturing of identity may indeed flourish here, but can still offer, however complexly, a place to live. This acknowledgement of new cultural overlaps and divides is valuable to the present time for many reasons, but not least because it is hardly one that belongs to exiles or immigrants alone.

To the contrary. We live today in a quintessentially suspicious time. I write these words in Washington, DC, a city where I have lived for almost fifteen years. Only in recent times have I needed to go through a traffic search to travel from one part of the city to another or been forced to walk through a metal detector to visit an art museum. Stranger still is the new function of overhead highway signs, which instead of advising drivers about accidents or congestion ahead, now frequently read 'HEIGHTENED SECURITY ALERT. REPORT SUSPICIOUS CONDITIONS' followed by a telephone number. Rather than make drivers work together to alleviate traffic conditions, these signs now work to keep us apart, suspicious of each other, making every person a potential agent of surveillance as well as a potential target.

I was shocked the first time I saw one of these signs. It simply did not seem like America, the only country I can claim to know as a native. Is my America

1. Quoted in Paula Harper, 'Visceral geometry', *Art in America*, vol. 86, no. 9, 1998, p. 106. Cf. Michael Thoss, 'The shared garden', in *Disorientation: Contemporary Arab Artists from the Middle East* (Berlin, House of World Art), p. 86.

also becoming an 'imaginary homeland'?[1] My situation is hardly comparable to the many peoples of the world who lack true political sovereignty, or those of migration and diaspora that have loomed so large in the past century. But it highlights the way these complexities of belonging can challenge us all, in some form, as well as the pressing power relations that underlie them. Rather than assume a unitary national identity, an unproblematic place to belong to, they hint at the exilic interior, part of the place in which Trinh T. Minh-Ha, the Vietnamese-American filmmaker, observed, 'There is a Third World in every First World, and vice versa.'[2] Hence another dimension of belonging: it is not just the individual, the would-be belonger, who is in flux, but also the home, the place of belonging itself. Paradoxically, the transnational state might be located within as well as without the nation.

I have just given some dramatic examples. However, belonging, and the sense of identity, or likeness that underpins it, has rarely been unproblematic during the ruptures, stratifications and complex changes of modern Western society. The American poet Wallace Stevens, for instance, described a sort of burlesque of this condition, a search for identity both necessary and incomplete, in a 1937 poem:

> To say of one mask it is like,
> To say of another it is like,
> To know that the balance does not quite rest
> That the mask is strange, however like.[3]

We might see these masks as works of art, and, like all works of art, as tokens of ourselves. However much the viewer wants to find community through likeness, there is an uneasiness, an estrangement, in his relation to the objects. The desire for belonging can be overtaken by a nostalgic desire for a time before dislocation (perhaps especially the dislocations of modernism). But looking for an unproblematic past can hardly obviate the quandary of the present. Rather, as Stevens's poem suggests, the important question is what, through art, we make of the current situation, and, conversely, what,

1. Salman Rushdie, *Imaginary Homelands* (London, Viking, 1991).
2. Quoted in James Clifford, 'On collecting art and culture', in idem, *The Predicament of Culture: Twentieth-Century Ethnography, Literature, and Art* (Cambridge, MA, Harvard University Press, 1989), p. 215.
3. Wallace Stevens, 'The man with the blue guitar', *Wallace Stevens: Collected Poetry and Prose* (New York, Library of America, 1997), p. 148.

in the current situation, we make of art.

Such uncertainty about or alienation from collective origin, nature and destiny is a given to much modern Western art. From the deliberate mystery of Paul Gauguin's 'manifesto' painting of 1898 entitled *Where do we come from? What are we? Where are we going?* through the song in Laurie Anderson's performance 'Empty Places' of 1989, which tells us 'We don't know where we come from/ We don't know what we are', one could chart a tradition of art made around such unknowing.[1] Incompleteness, uncertainty and indeed disenfranchisement of some sort may permeate a considerable portion of Western art, an art of unanswered questions situated within the social fractures that underlie the nation-states of Western society.

Yet even with such a precedent, the transnational dislocations of many contemporary world artists, described in the Sharjah Biennial programme statement as 'the urban nomads of our age', drive such a distinction to bold and frightening new degrees, in a way surely unimaginable to a late nineteenth-century Frenchman or to any unthinking citizen whose expectations are bounded within a global imperium. These dislocations present an opportunity to look anew at the global map, tracing onto its conventional objectivised borders, its locations of what is supposed to belong together and apart, another map, a subjectivised one of desires, longings and memories of places and people. It is not a map of what political leaders want us to accept as reality, but a much more complex one of what really exists for the citizens of the world.

For me, there is no artist whose work comes more readily to mind in this connection than Mona Hatoum. Perhaps it is no coincidence that a recent publication on this artist bore a title derived from Hugo of St Victor's maxim. Her remarkable *Map* (1998–9) is an arrangement of glass marbles on a floor in a way that clearly outlines major continents while also diminishing our commonly held distinctions between them. This is accomplished in two ways. First, the uniformity of the size and colour of the marbles unifies the global terrain in a way quite distinct from the familiar colour differentiation among countries and continents that is conventional to maps. Benedict Anderson locates the rise of modern Western mapping, with its careful distinctions of place and boundary, within the drive of the European powers in the nineteenth century towards assessing, distinguishing and ultimately

1. Laurie Anderson, *Empty Places: A Performance* (New York, Harper, 1991), p. 106.

taking power over the world beyond the European horizon.[1] Hatoum's more organic map, by contrast, is virtually a different world. It is not so much about borders and edges as about common land masses unified like the bodies of water with which they contrast. Moreover, it is a map that presents the world the way it actually appears to those privileged to see the earth in reality, as in views from space.

This leads to a second feature. By calling this map 'organic' I want to emphasise not only its paradoxical realism, but also its inherent openness to subjectivity. As viewers walk around the work, their pressure on the floor makes vibrations that can cause the marbles to roll, literally changing the outline of the world depicted. The act of viewing, then, itself becomes a sort of transnational movement, extending to the gallery viewer something like but even greater than the panoptic franchise of the viewpoint from space. In contrast with the daunting objectivity of political maps, Hatoum presents a subjective, even living map, which contains the same places but in the way we really know them, in relation to ourselves and our own changeable location. It is not a map where we can find our home or point of origin more easily, but rather, and far more valuably, one where we can locate ourselves, as we move, here, now.

Mona Hatoum's work is full of fascinating plays on mapping. It questions almost every aspect of the ostensible shared world the traditional map enforces. Her maps do not retreat from describing the world in familiar geographic terms; rather, they have additional elements which overlay, and undermine, established conventions. Especially important here is *Present Tense* (1996), designed from a map showing areas that were intended for Palestinian control according to the Oslo Accords. The map was made of indigenous products, soap and glass beads, and arranged on the floor of a gallery in an Arab quarter of Jerusalem.[2] The soap bore the unmistakable essence of the olive soap of Nablus and was recognised as such by Palestinian viewers. One viewer asked the artist, 'Did you draw the map on the soap because when it dissolves we won't have any of these stupid borders'?[3]

1. Benedict Anderson, *Imagined Communities: Reflections on the Origin and Spread of Nationalism,* rev. edn (London, Verso, 1991), esp. pp. 170–8.

2. The gallery referred to is Anadeel Gallery. See in this volume Jack Persekian 'A Place to Go' pp. 139–40 [Editor's note].

3. Michael Archer, Guy Brett, and Catherine de Zegher, *Mona Hatoum* (New York, Phaidon, 1997), p. 27. Cf. *Mona Hatoum: The Entire World as a Foreign Land* (London, Tate Gallery,

Playing immaterial subjectivities against the map's conventional material objectivity, these works of Mona Hatoum confront us with both likeness and strangeness. The places they map are very much the ones that we inhabit. Whether or not we belong in them, they represent a world that surely belongs to us. Furthermore, as *Present Tense* particularly shows, it is a conception that fuses uncertainties, fears about place, with physical, locational complexities involved in mapping.

These uncertainties, and their very real human costs, come to the fore in another work, which at least in the United States has done much to map a territory anew for viewers. Emily Jacir is a Palestinian American who was brought up in the Middle East, Europe and America. Her work, *Where We Come From* (2001–3), is nothing if not an essay on the paradoxes of belonging.[1] It has a very simple exposition. As a Palestinian artist with an American passport, Jacir can travel with relative ease to places other displaced Palestinians cannot go to, especially into and out of Israel and between the occupied territories. She asked a group of Palestinians, both in Palestine itself and elsewhere throughout the world, what she could do on their behalf while moving around the area. Their requests were heartbreakingly straightforward: to visit family villages, put flowers on a mother's grave, kick a soccer ball with whoever is around, look for someone's former house (which turned out to have been destroyed), eat a local specialty, pay a phone bill (from a man forbidden to go to the Jerusalem post office himself) and other largely mundane things. In each case, she documents the request, what kept the requesters from doing it themselves (primarily the person's identification card and political borders denied to it) and whether she was able to do what was asked. All accomplished requests were accompanied by photographs, taken from the artist's point of view (sometimes including her shadow) that would allow the requesters, or any other viewer, to project themselves into the occasion.

Like Hatoum's work, Jacir's also maps a subjectivity – in the painful overtones involved in the subject matter, the practices enforced on a people under external control – over the objectivity inherent in the mode of

2000). Another version of the *Map* can be viewed at http://artscenecal.com/ArtistsFiles/ HatoumM/HatoumMFile/HatoumMPics/MHatoum1.html. *Present Tense* is illustrated in D. O'Brien and D. Prochaska, *Beyond East and West: Seven Transnational Artists* (Exhibition catalogue, University of Illinois, 2004), pp. 86–7.

1. A considerable selection of the work is accessible online at http://www.universes-in-universe. de/islam/eng/2003/04/jacir/.

presentation, with its uniform museum-like wall panels of text and image. Yet in another sense, Jacir's work might be taken as the inverse of Hatoum's. Hatoum's works have a structural generality, as even her titles indicate. By contrast, Jacir's title mentions a people and a place, a 'we' and a 'where', and her work begins with a specific experience and allows the audience to move outward from there, by sympathy or association. It is an explicitly political work staged through a series of personal encounters. A common slogan of the protests against American intervention in the Middle East is 'We are all Palestinians'. Jacir's work allows us to see what that could mean: to be a Palestinian, held by political boundaries from performing everyday actions for family, work, and pleasure. Hatoum's work, by contrast, does not explicitly present a single cultural locale, but rather a field on which such cultural identities can, and do, take root.

Both artists construct powerful sites for considering questions of belonging and identity. But they go about these tasks in opposite ways, from the particular to the general, or vice versa. I have described their works in some detail for just this reason. They exemplify how the two fundamental kinds of logical operation, induction and deduction, may be used for the quarrying of identity. In the process, their subjects are different as well: ranging from redescribing place to reconnecting the experiences of a people. Put another way, both artists are traffickers in the medium of things that can be used to define earthly belonging: from dotted lines to everyday objects to human interactions, from borders to boarders of the world.

I have concentrated on two artists with Middle Eastern connection, but such questioning of identity takes place in art around the globe. Moreover, as already intimated, this activity can be conceived not just in contrast to supposed Western norms, but also in connection with the West itself. This new interest in questioning may well be symptomatic of the rise of globalisation itself, of the same encumberment of differing cultural traditions noted by Said and further enabled by contemporary systems for communication, transport and display. However related, though, the forms of questioning identity and belonging are as varied as the cultural spaces in which they take place. I can give only one example, but I hope it can again stand for a broader range of production.

Paradise Now? was a recent exhibit of contemporary art from the Pacific. As the title suggests, it explicitly presented its objects within a project of

questioning an inherited sense of a region.[1] Among the artists whose work springs from the clash of materials and identities in places like Fiji, Samoa and New Zealand was the collaborative production of some Hawai'i artists, critics, teachers and activists who work under the collective name Downwind Productions.

The work of Downwind Productions is a remarkable product of both mimicry and subversion of touristic Hawai'i, in the process working to re-establish, piece by piece, the former life of a long-established community. Not the least of their works is a series of four mass-produced packets sold in tourist shops (and available by secure credit card purchase on their web site), promising, and delivering, 'an *authentic piece* of Wakiki's past'. Each package contains a tiny bit of concrete, a relic of the waves of overbuilding Hawai'i into a vast tourist resort. The keepsake is accompanied by a warning 'Please do not ingest the concrete. It is a metaphor of, not an object for, reckless consumption.' The real treasure of the packet is the accompanying sheet which invites the tourist, gently but seriously, to consider the history of where he or she now walks: the cemeteries paved over for car parks, self-sustaining agriculture despoiled for monocultural pineapple planting, and deracinations and dependencies of native culture in the face of touristic capitalism.

I choose this production for a number of reasons, among them its own inherent brilliance and the fact that here the question of belonging, identity and exclusion is imbricated deeply within the West. (Hawai'i is now an American state, after all, having been forcibly removed from its previous existence as a sovereign island nation.) But most important in the present context about this work of Downwind Productions is that it involves a sort of mutual dependency. Who belongs to whom? Each cultural identity, the native of Hawai'i and modern Western capitalist, inscribes themself through the other. The American appropriation of Hawai'i is a past fact. The work of Downwind Productions is a supplemental present, a sort of inscribing back that is both playful and serious, through the language of marketing, entangling from the other side the vexed relation of coloniser and colonised.[2]

1. *Paradise Now?: Contemporary Art from the Pacific* (exhibit) (New York, Asia Society, 2004). For Downwind Productions, see pp. 64–5. See also their impressive web site, www.downwindproductions.com.
2. Nicholas Thomas, *Entangled Objects: Exchange, Material Culture, and Colonialism in the Pacific* (Cambridge, MA, Harvard University Press, 1991); idem, *Colonialism's Culture:*

To underscore the dependency between the cultures involved in such a project cannot be to place both parties at the same level or to minimise the violence (both figurative and real) historically involved in the transaction. Rather, it is to deconstruct the conception of either party (modern or indigenous) as unitary or timeless. Today one need not (and perhaps cannot) belong to just one or the other. Whatever they were before the current state of contact and conflict, this pairing of traditions is now the basis for a range of cultural identities, of locations between the two antipodes that can only be called *hybrid*. This is the foreign land, foreign in some degree to all parties, on which communities and identities are staged in Hawai'i. Such a conception does not minimise cultural difference but rather emphasises the perpetual play of difference at every position in the range of cultural action. Its ultimate force is to highlight a view of cultural identity that is not simply binary but fundamentally, complexly plural and fractured.

Such a view seems to me indeed appropriate for the 'revolutionary realities today' mentioned by Said and to exemplify the encumbering he mentioned. But this view is important also because it helps us to see history itself anew, finding tendencies beyond the dominant trends of nineteenth-century Orientalist thought in France and England. Not long ago I finished an essay on the nineteenth-century imagery of a particular spot in Istanbul and was fascinated to find a subtly different approach to it from German writers, an approach that dissolves the power of binaries. It can be summed up with the words of Goethe, from his *West-Östlicher Divan* of 1819: '*Wer sich selbst und andre kennt/ Wird auch hier erkennen/ Orient und Okzident/ Sind nicht mehr zu trennen*' ('Who is familiar with himself as well as someone else/ will understand in this case also [that]/ Orient and Occident/ can no more be divided'). As I noted then, Goethe's work assumes a worldliness and circulation whose ultimate effect is to dissolve the deeply judgemental, Manichaean division between East and West, representing the relationship instead as something mutually and universally understandable.[1] This maxim, from the very start of the nineteenth century, offers a glimpse of an alternative

Anthropology, Travel, and Government (Princeton, NJ, Princeton University Press, 1994).

1. J. W. von Goethe, 'West-Östlicher divan', *Goethes Werke*, ed. R. Müller-Freienfeld (Berlin, Wegweiser Verlag, 1923), p. 149. My own essay is 'The sweet waters of Asia: representing difference/differencing representation in nineteenth-century Turkey', *Edges of Empire: Orientalism and Visual Culture*, ed. J. Hackforth-Jones and M. Roberts (London, Blackwell, forthcoming 2005).

history to the hegemonic and demonising insistence of Western writing about the Orient of the time that is most often cited today. This is essential too for the present, demonstrating that there are other pasts that new present realities may help us find.

In fact, I choose this quotation as much for its force in more recent history. On 12 July 2000, in Weimar, Germany, Goethe's renowned home city, the maxim quoted above was recited by Mohammed Khatami, president of the Islamic Republic of Iran. The occasion was the unveiling of a monument dedicated by the German government to both Goethe and Hafez, the great Persian poet whose work was a central inspiration for Goethe.[1] These words, and the relation they describe, were hailed, indeed monumentalised, in a notable gesture of cultural overlap. They still stand today.

But how can we find them in the landscape after September 11, in which all is made to seem not just foreign but threatening? I have no complete answer to this, but I suspect part of it is to realise the complex varieties of identity commonly practised today. To this end, I conclude with a story. The day after the attacks of September 11, Moukhtar Kocache, Lebanese by birth, was searching amid the rubble of lower Manhattan for a missing colleague.[2] He heard a well-dressed man on a mobile phone say something about how America should bomb all Arabs and told the man he thought his comment was racist and offensive. The man responded with an ugly barrage of insults. A nearby police officer said nothing. This might seem a stereotypical confrontation, but it was actually nothing of the kind. The first impression one might have had of the identity of each person was, at best, incomplete.

The policeman later shook Kocache's hand, and while he was speaking a woman came up to him and spoke to him in Hebrew. She then turned to Kocache and comforted him in fluent Arabic. She was from Yemen. 'So the Arab turns out to be a New Yorker,' said Kocache, referring to himself. 'The Israeli [the woman] turns out to be an Arab, and the New Yorker [the police officer] turns out to be an Israeli.' Kocache drew a fascinating conclusion from this. 'The reason I'm a New Yorker is I can practise a number of identities,' he said. 'I am an Arab American ... I have made a home here. I am British

1. On the event, see www.iranembassy.de/d-wirtschaft/eishel-iran.htm.
2. 'For some in US, grief over attacks is followed by fear', *Washington Post*, 22 September 2001, p. A16.

by passport. I'm French because I have lived most of my life in France. I'm a vegetarian by choice. Our identities are hybrid. I will defend all of them.'

In simply describing his life, Kocache articulates a complex territory for negotiating forms of identity and belonging. This range of communities given, made and imagined is fascinatingly rich with possibility and eminently worth defending. An art that engages with, or that even makes itself from the many places, identities and cultures to be found therein, one that helps us to be cognisant of the whole, to get to know the particular places and histories embedded in the terrain, and to be part of their present and future, is a vital one for all of us.

The Globalisation of Art

Achille Bonito Oliva

The posthistory of art

We have grown accustomed to hearing European art theorists debate that the 'death of art' will be its absorption into the realm of philosophy. In any case, their common ground, whether Marxist or not, was a conception of creation as being progressively absorbed by all-consuming technical development. Nonetheless, all contemporary art, from Impressionism to the present day, from the second half of nineteenth century to the end of the twentieth, had sounded like the artist's challenge to an age characterised by technical reproducibility. The evolutionistic meaning of contemporaneity was thus supported by the ideology of 'linguistic Darwinism', stemming from conceiving research as linear and progress as historically determined. Historical progress and the development of artistic languages de facto converged, both pointing at a productive and experimental optimism about society and the art it expressed.

The paradigmatic crisis of the 1970s called for a revision in the artistic field: the movement from neo-avant-garde's 'evolutionary' linearity to trans-avant-garde's eclectic progression. To some, the end of the *grands récits* meant the much-longed-for 'death of art', absorbed by the inexorable analytic nature that undoubtedly characterises the culture of technology.

Credit goes to Arthur Danto for having immediately grasped this: the shifting of art from history to an inner posthistory that guaranteed its existence and granted it a happy discontinuous continuity. Through his complex philosophical pragmatism, the American scholar provided us with an original way of looking at art, granting its nomadic nature and a peculiar

investigative spirit. Though at first conceiving art as philosophy, Danto later settled for a more elaborate concept, since it is through art's inner development that the real philosophical question about the nature of art had emerged.

Danto followed an anti-European line of reasoning (the European conception, dominated by Croce's historicism and phenomenology, sees a cognitive experience in the aesthetic event) and developed a kind of theoretical continuity starting from Dewey and a philosophical pragmatism in which aesthetic and practical values, creative experience and daily life are never apart. That is why Danto affirms the value of contemporary art and its spiritual ability to influence our ways of living through its forms.

Within this theoretical framework, this American scholar fosters an anthropological conception following which the creative process, like a fertile metamorphosis, includes in itself evidence of its own reality through form. Form is transmuted into style in time, thereby constituting visual evidence that there has been a transformation of life.

Whereas socialist realism established itself as an apology of existence, an activity that is functional and a slave to the metaphysical entity constituted by ideology, Danto's theory states the ambivalence of art's autonomy and its interaction with the world that surrounds it.

It is not the superb hegemonic value of the creative process that is being celebrated here, rather it is the force with which the aesthetic experience modifies our daily experiences. Accordingly, it is pointed out how an artist's strategy can be permanently accompanied throughout the complexities of a universe dominated by telematics.

Telematics tends to inevitably develop an *anorexia principle*, whereby the substance of the object is dissolved, so that real data can be better and more easily irradiated as pure information. Art does not mimic the process through which the object disappears; on the contrary, it opposes it with a spirit of resistance, as, far from affirming a simple and statistical informative value, it displays the more complex value of communication.

This last occurs not only by way of linguistic elaboration, but also through effectively choosing a subject matter that exalts the *hic et nunc* of the artist in his or her context, in other words the spiritual elaboration of issues dealing with our life, such as sexuality and the problems related to the body and to illness.

It is here that plain information on world news is transformed into a *formal thesis* (Haim Steinbach) that can and does influence collective consciousness through art's creative process, which, in turn, never constitutes a statistical appearance, but rather a metamorphosis towards what is persistent. It is a work affirming a process from space into time, from gesture towards duration.

Thus, the *visibility of art* is measured through the texture of form, which can witness the happy and tiring burden of living and the redemption of the present's temporal verticality into the horizontal yet complex bounds of history. Posthistory is a good trick for defeating the destructive desperation of pure present through time.

The diaspora of art

The end of the twentieth century and of the second millennium, as well as the first decade of the third, are dominated by an internal tension created by a double movement: *globalisation* and *tribalisation*.

Technological development and telematics tend to unify all industrial and craftwork production, as well as economy and culture. A strong interdependence affects the development of society, placing it under the mark of standardisation and multiculturalism. The driving force behind productive dynamics is a horizontal trend, and this is what is weakening any attempt at diversifying the product and, as a consequence, its producer.

Globalisation threatens identity in that it eliminates any attempt at personalising one's existence. The counteraction is *tribalisation*, a frequently reactionary and regressive response, the rebirth of nationalisms and integralisms, and a new value attributed to stability. To the macro event bringing forth technological development, man answers with the micro event of his individual existence, linked both to a settling resistance and to a refusal of acknowledging the presence of any threatening micro events produced by individuals in the same environment.

Many contemporary artists straddle the fence, claiming their right to produce their own imagery saved from the two extremes of globalisation and tribalisation. They adopt a tactic marked by cultural nomadism to escape the perverse consequence of tribal identity and, at the same time, claim the creation of what is symbol against the commoditisation of global economy.

Thus, artists exercise their right to diaspora, their freedom to wander across the boundaries of various cultures, nations and media forms. They refuse the idea of belonging and choose to deny the value of space, habitat and related anthropology in favour of the value of time condensed in the form of their work.

Stoically, these artists freely choose diaspora, the tragic historical fate suffered by many populations of both East and West. In this sense, a work of art acquires a utopian quality in its etymological significance, that is, the preference for a 'non-place', a *dematerialised elsewhere* that does not require settlement or occupation.

Many artists develop the same concept of *decomposition*, the positive emancipation from conceiving a single formal option, the confirmation of the drift and the trespassing of the borders, through different languages, into complex works.

Painting, sculpture, photography, video, music, drawing and architecture all intermingle to create installations that are able to fill any space without running the risk of being totally integrated. The nomadic nature and eclectic style that support form help to define the gradual breaking down of both the productive moment – as to the spatial unity – and the contemplative moment – as to the temporal unity.

A work of art comes to function much like a mixer, blending together diverse languages while causing traditional aesthetic categories to dematerialise. It acts on the viewing public with the alienating force of reality in motion, by the ability to affirm its own lack of consensus. Its consistent nature of diaspora springs from a tradition going from the historical avant-garde to trans-avant-garde, and it witnesses that art is autonomous and that it cannot operate according to the principles of identification. Contemporary art successfully exploits the overcoming of traditional barriers, to gain access to the rapidity of itineraries that play on the principle of contamination. This principle counters the risk of standardisation, which is the consequence of telecommunication and globalisation. On the one hand, such a principle makes the most of trespassing and cultural interaction; on the other hand, it affirms that the individual artist has the right to produce unexpected and amazing forms, stemming from a symbolic scheme that is free from hierarchy.

Art operates also on a further level of decomposition, by asserting the

creative value of the singular 'I' as opposed to the quantitative value of the plural 'we'. The ordinary viewing public can contemplate the traces of its diaspora, those visible signs of trespassing that give the work of art a positively foreign appearance, when compared with the familiar televised images that daily pervade the private space of mass society. Diaspora implies a complexity of multiple references and the memories of the various relations characterising the artist's cultural nomadism, such complexity being designed against the spectacular simplification of images with which the small television screen bombards us every day.

The ambivalent nature of the work of art is an overt manifestation of these artists' resistance to the reality surrounding them; it is the formalisation of the hostility of an art form that has absolutely no desire to perform any informative service. Quite the opposite: this art aims to interrupt the trend of a universe that is based on the myth of information. And yet these artists are aware of the problem of communication, and they acknowledge that telecommunication controls the world. That is the reason why they absorb into their work the spurious diversity of differentiated languages, though forging it out and away from any immediate consumption. Communication, by definition, must in some way adopt techniques and materials belonging to the context in which we live. It means placing the diaspora system under the control of a discipline that would allow it to develop a contact with the public. After such a long diaspora, art wonders whether to have a break, to avoid the dangers of an abstract globalisation and the international fruition of art's system, promoting a balanced communication, away from the temptation of an easy tribal call.

Such a call always implies the acceptance of belonging, together with a notion of consumption that intertwines with a quest for consensus in some artistic forms. The balancing of form ensures that art does not become a mere object to be used and allows it to keep its *transient nature*, typical of a long journey in which only short breaks can be taken.

The art at the end of last century was to hold fast to its diaspora quality, the fate of an excellent never-ending movement, in order to witness its own structural attitude, which is both destructuring and cross-eyed. This was the only way that these artists could demonstrate the recognition they were giving time, by freezing a better time in works that clearly highlighted the faith they had in history.

Art

There is no such thing as an art's intellectual consciousness; rather, there exists the consciousness of a work of art that is able to formulate a vision of the world far beyond its creator. One clear example of this is the French writer Balzac, a conservative writer whose novels, like a fresco, are a critical and in-depth social description of his times.

In figurative art, it is mannerism that establishes a peculiar intellectual consciousness that meditates on its metalinguistic nature and the artist's relationship with the outside world. To better develop this position, which visually represents and interprets the world without being censored by authority, the mannerist artist assumes a lateral position from where she or he can observe the dynamics of history and elaborate a linguistic medium through which to represent her or his dissent. The metaphoric action of art, which lies within its representation, is by nature indirect and unlike practical action that requires determination and a frontal approach. By choosing a lateral position, the artist takes up the role typical of a traitor, who looks at the world without accepting it, who wants to change it, though without taking action. The artist rather produces an iconographic reservoir, a storehouse of images that express and protect the critical and self-reflective intellectual consciousness.

The stoic firmness of this position stems from the artist's awareness of his or her operating through metaphor and allegory, though this does not necessarily imply an agnostic or neutral attitude towards the world. The historical avant-garde movements of the twentieth century and their explicit manifestos, their declarations of collective poetics appealing to and able of drawing together crowds of artists, seemed determined to reverse their lateral strategy into a frontal declaration of war on society. It is the metalinguistic consciousness of art, whose reality is language, that persists in all these movements up to neo-avant-gardes and trans-avant-gardes, compelling artists to accept the inevitability of the power of image, bound to critical representation rather than to subversive action.

Up to the 1980s, art succeeded in creating itself as something different from show business society, thereby manifesting a clear and evident level of analysis. But just as telecommunication technology turns everyday life into something aesthetic, and every democracy into a 'tele-cracy', it is becoming

increasingly more difficult to keep a critical ratio clearly defined. Artistic form is under constant assault by an industrial production of images that creates a superficial synthesis of the arts, programmatically promoted by the historical avant-gardes as a way to release formal totality from everyday partiality.

But how can today's art preserve its intellectual consciousness and represent it, when technological research is being used by the industrial system as a means to achieve spectacular ends? In past times, experimenting with new techniques and materials was a symptom of such intellectual consciousness. Artists would work in a sort of 'workshop of images', and this was supposed to be the difference compared with everyday production: it was quality making a stand against the invasion of quantity. This was the case with art being produced from the postwar period up to the 1980s. Now it seems that the space for projects has become even more limited, and all that is left is the subjective intention of a work entrusted to the 'soft project' constituted by the creative process. What comes out of this is the making of a formal order that is meant to be visible moral resistance against a chaotic and fragmentary outside world.

Though tactically adopting the features of stylistic eclecticism – contamination, destructuring, assemblage and reconversion of linguistic fragments coming from a variety of sources – the work of art always accepts a formal layout that serves a different intention in the end. This intention stems from the artist's need to express an explicit level of resistance through form.

This intention documents a broad conceptual ratio that neither weakens the temperature of the work nor reduces it to pure didactic declaration or platonic statement on poetics. It is precisely the achievement of a formal result that convincingly expresses the final outcome of the creative process, the passage from the artist's intention to the artwork's intention, and this results in a clear quality of resistance. This quality is even strengthened by a strong and meaningful conceptual support, acting like a skeleton holding up the weight of the flesh.

Now, at the beginning of the new millennium, art constitutes – at its best – the by-product of a sharp though cold intellectual awareness of the world. It does not fall into the metaphysical trap of formal production far removed from what is normally seen every day. Rather, it adopts a methodological inversion, assuming a lateral position, a kind of backing of daily life, which

camouflages it and preserves it. Adopting this tactic means using the strategy of an opportune betrayal, similar to that of the *toreador* who, by sidestepping, is in a position where he may better wound the bull. Intellectual consciousness, therefore, means being aware of the enemy, having a clear vision of the complexities of the social system and of its international standardisation in a circuit where the eye is stimulated much more than consciousness is.

Certainly this involves a shifting of the artist from distant pathos to the position of a more cynical betrayal, motivated by his or her acceptance of a terrifying historical perdition, in which the artwork seems destined to undergo vicissitudes heralding mere exploitation.

And yet the artist keeps producing his or her forms and objects. Evidently, the artist feels he or she is accumulating traces of a subjective resistance by freezing the idea of art for future reference. This stoic exercise is not so much meant as a means to save a race on its way to extinction, but rather it springs from a need to keep the artist's role alive.

Art history provides us with numerous examples, passed down from the artwork's immortality, of a creative role wielded against the power of the present to defend future possibilities: time against space. This lesson seems to have been adopted by today's art, which continues to accumulate formal reservoirs inside a space that is already congested, probably hoping that a better – and perhaps less jumbled and contradictory – time will come. The artists' resistance is obvious here, the proof being in their production of forms that place greater emphasis on a conceptual level of internal difference than on that which is spectacularly external. By reducing its eventual metaphysical spectacularity, art aims at eliciting in the viewer the silent dignity of a slow and progressive reflection, the contemplation of a state of different visibility.

Seeing is believing. At a time when there seems to be no more room for any kind of belief, a lay suspicion of a better time appears. A time of transparency and simplicity, indulgent and inviting introspection, and the chance to organise everyday life into forms suitable to the inner view of a consciousness that brings the creator of art and his or her rewarded recipient together into one shared space.

Translated from Italian by Christine Anne di Staola and Rossella Pacilio

Belonging and *Not* Belonging[1]

Laymert Garcia dos Santos

The French philosopher Gilles Deleuze once wrote that 'in capitalism, only one thing is universal – the market'.[2] The statement may seem obvious, but its implications are far from trivial. For if the market is the ultimate reference, then abstract value is the only value that matters and the one against which all values are measured. This is why, after their late 1970s analysis of savage and barbarian societies in *Anti-Oedipus: Capitalism and Schziophrenia,* Deleuze and Félix Guattari characterised civilised society as the *socius* ruled by decodification and deterritorialisation. Given that capitalism is the encounter between the salesman of abstract manpower and the representative of capital, there is no escaping an assault upon the dynamics of abstract valorisation (that is, value + value), which disqualifies every manner of belonging.

In the farthest reaches of the Amazon on the border between Brazil and Venezuela, amid the vastness of the tropical forest, Davi Kopenawa draws lines on the hard village soil in an attempt to explain the difference between his society and ours, which he understands to be the role of money. In so doing, he unwittingly appears to reinvent, before our astonished eyes, a sort of critique of political economy. In effect, what is the Indian chief doing if not opposing the values of his culture to value itself? The Yanomami are among the planet's most traditional peoples and were able to preserve their original society until just a few decades ago. As a semi-nomadic people, they still maintain a relationship with land that is the opposite of our own:

1. Portions of this text have been published in German as 'Europa aus der sicht des Südens', in *Via Regia,* vol. 52–53, Erfurt, Europäischen Kultur-und Informationzentrum in Thüringen, July/August 1997–May 1998, pp. 31–8.
2. Gilles Deleuze, *Pourparlers* (Paris, Minuit, 1990), p. 233.

whereas we regard land as belonging to us, the Yanomami belong to the land. And it is by virtue of this difference, that land could be someone's property, that it is difficult to make them understand the meaning of the demarcation of their territory. To them territory is something alive, like them and thus capable of change and movement, in permanent transformation, not an inert plot of land on which to live. From this viewpoint, it would make no sense at all to stop in the middle of the forest, to draw an imaginary line and declare that it must not be crossed because it signals a correspondence with the place at which their territory ends. And when the Yanomami understand that the territory defined 'belongs' to them and that they must defend it against invaders, they are immediately confronted with the paradoxical need to fight for 'their' land in order to continue to belong to it.

The Yanomami example is interesting because it clarifies the problem of belonging by contrasting the 'primitive territorial machine' with the 'civilised capitalist machine'. In the former, man's foundational relationship is with the land; in the latter, it is with abstract value. If this is true, it begs the question: how is it possible to 'belong', in the age of globalised capitalism, other than in a proprietary sense? Can belonging – to a country, to a people, to a nation – still make sense? Would it not be preferable to focus on not belonging, that is, to consider those contemporary processes that reveal the primacy of increased deterritorialisation rather than to privilege the reterritorialisation that capitalism's very axiomatics engender with regard to its continuous expansion?

The accelerated transformation that the alliance of techno-science with global capital has been imprinting on the contemporary world, and the impact it has exerted on the process of psychic and collective individuation, can no longer be ignored. Language itself signals the movement – *de*territorialisation, *de*codification, *de*construction, *di*splacement, *de*-industrialisation, *un*employment, *post*history, *post*modernism, *post*-human. A vast abstract drift seems to drag everything and everyone along with it. If we 'belong' to it, more than to any other other territory we may have had, the main question to ask might be: where does that leave us?

This essay explores two contradictory impressions engendered through exposure to contemporary works of art that refer specifically to a relationship of belonging that is forged between the citizen and the nation-state.

The first impression was brought about by *Citizen*, a 1996 photograph by Jeff Wall. It depicts from a distance an anonymous citizen sleeping in an unspecified public park. We immediately realise that the figure is not a street dweller, one of the excluded who 'belong' to the city and transgress the borderlines between the public and the private. And we know it not only because of the work's title, but also because the body, the posture and the clothing are unmistakable, accumulated signs that we see before us a common man. However, what most strongly draws our attention is his attitude of surrender. In effect, everything seems to converge towards the way the citizen surrenders himself to sleep, naturally, a sense that he is at home within the public space. This naturalness astonishes us because it intensely expresses the relationship of mutual belonging that is established between the citizen and space of citizenship. The man is able to surrender because he trusts that the space welcomes him and that nothing in it can threaten his integrity. The man behaves as if the space belongs to him; paradoxically, however, what we see is the opposite – it is because he feels unquestionably part of the public space that he can adopt this posture. Otherwise, how can we explain that the citizen has forsaken consciousness (his highest prerogative) and allowed himself to remain thus, unconscious and defenceless? There is a total integration of man and landscape, of figure and background – they exist for one another, an evidently ideal integration, a pure manifestation of a peaceful relationship, the ironic illustration of a borderline relationship that disturbs us because it has the concreteness of a waking dream.

This emblematic expression of the citizen's belonging to the space of citizenship refutes the impression created by two works exhibited simultaneously at the 45th Venice Biennial in 1993, both of which reveal the awakening of the artists who created them to the rupture between the citizen and the nation-state that became pronounced in the 1990s. I refer here to the works by the Russian artist Ilya Kabakov and the German artist Hans Haacke. The critic Andrew Graham-Dixon has described them as follows:

> Kabakov had turned the Russian pavilion into a building site: a
> wooden palisade surrounded the neoclassical building; a hand-

painted sign showed you where to enter. You found yourself in a darkened corridor lit by a single light bulb, full of rubble, paint pots, brushes, bits of cloth and all the detritus that painter decorators leave around when they have not yet completed their work. The central hall, pitch-dark, was occupied by a large and ramshackle edifice of scaffolding past which visitors had to walk in single file before finding themselves, suddenly, out in the open air, standing on a balcony at the back of the building. Looking down into the garden, they could then see a small plywood model of the building they had just left, fitted with loudspeakers, blaring out a tinny recording of Soviet military music of the 1950s. The message was clear and brutal: modern Russia is a deserted building, the people trying to rebuild it have given up half-way through, and the socialist project of the past became an archaism and a cruel, absurd misunderstanding.[1]

Haacke had also taken the German pavilion as an emblem of his country, by converting it into another kind of ruin. As Graham-Dixon points out, 'he has responded to the grandiose architecture with admirable straightforwardness by taking the floor up. But he has also had the broken floor tiles left in situ, heaped in uneven tiles that visitors walk on and over: the result is a perpetual crash and thunder like the sound of crockery being smashed. On the far wall of this enormous room Haacke has simply placed a large inscription which reads "Germania".' Like modern Russia, concludes Graham-Dixon, modern Germany is represented as a ruin, 'but one that makes the viewer complicit in its ruination, a participant in the crashing chaos that he witnesses'.[2]

The engenderment of ruin by history has been a recurrent theme in European culture since the eighteenth century. To a citizen of the Third World, however, the most impressive and intriguing thing about these works is not the broad range of allusions they contain but, rather, the very contemporary tension they generate through their synchronicity with European space and time. References to the disintegration of the Soviet Union, to the interrupted

1. Andrew Graham-Dixon, 'Sunk under the weight of culture', The Independent, 15 June 1993, p. 14.
2. Ibid.

process of socialism and to the interruption of projected social reforms are easily enough understood; however, it was not so easy to perceive that Germany lay in ruins, particularly not when it was asserting itself as one of the leading exponents of high capitalism, had recently concluded a process of reunification and was engaged in rebuilding its eastern territory. How to perceive as ruined that which was rediscovering itself and proposing to rebuild itself? The problem is all the more intriguing because it is clear that the ruined Germany to which the artist refers is not the Germany that Western visitors discovered in the East; the desolate landscape was, in fact, that of West Germany. However, because it was imperceptible and hidden behind material abundance, it now needed to be exposed. Moreover, Haacke's work is shocking because it completely subverted the image that Germany projects to Germans themselves, as well as to Europeans and to the entire world. Finally, there is the problem of the articulation between the Russian ruin and the German ruin, for the existence and co-experience of both works do not appear to be a matter of mere coincidence. As viewed by the South, an articulation of this sort seems doubly disastrous, for it suggests to developing countries that the evolution of capitalism in Germany and the attempt to find alternative ways of developing the Soviet Union had *simultaneously* caused the ruin of both countries. It suddenly seemed as if developing countries had lost the only two models that might provide them with a framework for their own modernisation and development.

For Brazilians, this loss has tremendous, far-reaching implications, because it signals a possible loss of our own future. In a penetrating analysis, the Brazilian anthropologist Darcy Ribeiro shows how the Brazilian people have been formed by a process of cultural and territorial uprooting of three ethnic groups: Indians (drawn out of their traditional communities and deprived of their own land), Black Africans (torn from their tribes and exported to the New World as slaves) and European peasants (drawn from their tracts of land and made over as adventurers). In grinding down and blending the original matrices into a new ethnic entity, colonisation bred an uprooted people without a culture of their own, without ties to land or tradition, a new people with a remarkable feature. According to Ribeiro, Brazil is not merely an ethnic group but rather a national ethnic group, a 'people-nation' settled within a territory of its own, framed by a single state, pursuing its own destiny. Unlike Spain in Europe or Guatemala in Central America, for

instance – multi-ethnic societies ruled by unitary states and therefore torn by inter-ethnic conflicts – Brazil is a single national ethnic group. Its population is incorporated into a unified nation, a uni-ethnic state, the only exception being the various micro-ethnic tribal groups, so imponderable that their existence does not affect the national destiny.[1]

However, the members of this 'people-nation', this eminently modern people, do not exist for themselves, because they have always been a degraded labour force at the service of external interests and of an elite that acts as local representative to these very interests. Ribeiro's analysis assumes implicitly that, in order to live for themselves, Brazilians must cease being a people for others in order to have their identity acknowledged and valued as a Brazilian nation and state. Quite obviously, this means that their vocation would be to build a country of their own – in other words, to belong to themselves.

It is no coincidence that building a modern country has become a veritable obsession for Brazilian society. Although there may be some divergence as to how such a process should be carried out, the need for it is apparently unquestioned. In this context, the works of Kabakov and Haacke lead to the pertinent question of whether it is still possible to build a nation at all and (to pursue this same line of inquiry) whether it might still be possible to rebuild a nation. Should neither possibility exist, what were the disrupting forces that brought about the ruin of the USSR, the ruin of Germany and the ruin of Brazil, a nation that has never 'fully' existed?

Brazil continues to see itself as a sort of tomorrowland, which might explain why Brazilians do not realise that they cannot simultaneously belong to themselves and to their country. In his book *Der Kollaps der Modernisierung*,[2] the German sociologist Robert Kurz opened our eyes to the possibility that efforts to develop the Third World can no longer be assumed to bring about the promised modernisation of society, and with

1. Darcy Ribeiro, *The Brazilian People – The Formation and Meaning of Brazil*, tr. Gregory Rabassa (University of Florida, Center for Latin American Studies, 2000).
2. Robert Kurz, *O Colapso da Modernização* ('The Collapse of Modernization'), tr. Karen E. Barbosa, 3d edn (Rio de Janeiro, Paz e Terra, 1993). [Originally published as *Der Kollaps der Modernisierung* (Frankfurt, Vito von Eichborn GmbH & Co. and Verlag KG, 1991).]

that realisation, we discover that our project for the future has fallen by the wayside and that we are living in a 'society of postcatastrophe', one that is ruled by a dynamic of dismantlement. Thus, Brazilians who are alert to the signs of this catastrophe – growing unemployment, violence and poverty; increased de-industrialisation and debt; the closing down of institutions and public services; the diminished role of government in various regions; environmental degradation; the devastation of the Amazon forest and the invasion of indigenous reservations; the de-structuring of urban spaces; the growing role of drug dealing and organised crime in urban life – Brazilians who are alert, principally, to the conversion of ever-increasing segments of the population into social nonbeings, that is, into 'monetary subjects without money' (Kurz's words), may well wonder:

> If it is true that modernisation has taken a toll we cannot afford to pay and has not provided the promised jobs and citizenship, what is to become of us? What will we think of it all? The myth of a providential convergence between progress and a developing Brazilian society no longer seems plausible. What if the aspect of modernisation allocated to us (as well as to others) is the dismantlement, now taking place, both outside and within us? And who would we be in this process?[1]

The disturbing questions posed by Roberto Schwarz (namely, what to think if modernisation is, indeed, over and done with and, second, who would we be during the process of dismantlement?) point to the unprecedented and uncomfortable situation in which we find ourselves. We can clearly see how displaced the aspiration of modernity is for us all, and we can no longer rely on previously existing parameters, when we believed we could develop, modernise and build up our country in the future. It was as if the historical process we were experiencing had somehow been turned around and, along with it, our own idea of ourselves and of our role; as if the revoked myth of a possible convergence between Brazilian society and progress had opened up a vertiginous perspective, of which we are only able to detect, temporarily, negative aspects or shards of that which was shattered. Whereas the view of belonging to a postcatastrophic society does not specifically shed much light on this lack of perspective, it does point to a rise in a sort of nihilism that

1. Roberto Schwarz, 'Ainda sobre o livro de Kurz' ('Still on the Book by Kurz'), Novos Estudos Cebrap, no. 37 (São Paulo, 1993), p. 137. Author's italics.

may be worth considering. One wonders whether such nihilism might not anticipate, to a degree, the sort of nihilism that could arise in other ruined nations if it becomes clear to them that this myth of a convergence between progress and society is being revoked.

Although the collapse of modernisation first became obvious in Third World societies, Kurz believes that it is by no means restricted to them. According to Kurz, both the downfall of socialism in the East and the problems faced by developed countries are part of an identical process he calls the 'crisis of the working society'. And the cause of this crisis is the same everywhere. For the first time in history, the now-globalised capitalist system is excluding (rather than including) larger and larger segments of the working force. This is so because competition in the world market (in addition to the association of techno-science and globalised capital) imposes such high standards of productivity that the system's very logic eventually renders it not only destructive but also (and above all) self-destructive. At the precise moment that capitalism appears to have triumphed across the world, Kurz argues that the evolution of the capitalist system has reached a limit. And it is both ironic and paradoxical that such a limit arises precisely as techno-science (which rejects any limitation to research and development) merges, in a single move, with an economic rationale that rejects the mere notion of any limits to capital.

In his last writings and interviews, the German poet and playwright Heiner Müller reiterated the theme of the impact that technology has made upon society and the implacable logic that it simultaneously revealed and consummated. In his comments on Ernest Jünger's theory (that the Nazi strategy of genocide deprived the Wehrmacht of the means of transportation they needed for victory), Müller observes:

> He did not understand that the Nazis' military doctrine was based on the strategic concept of total acceleration. The problem was neither the Wehrmacht's defeat of the Red Army nor Rommel's defeat of Montgomery. That was merely the superficial aspect, the theatre of war. On the contrary, its reality was totally economic and

technological, a matter of testing the technology, of introducing
the technology into everyday life, of technicising life. All attempts
at total acceleration find their principal opponent in minorities. For
minorities have always represented something autonomous; they are
an obstacle to acceleration. Minorities are brakes, hence the need to
annihilate them, for they persist in maintaining their own speed.[1]

Müller's observation provides a new criterion, selection, according to
which we might consider the problem of exclusion in the society of global
capitalism. As demanded by economic acceleration and total technology,
selection would be a way of 'processing' social categories and populations
according to two registers. The first would neutralise (if not annihilate)
those who exclude themselves or who are excluded by the total movement,
either because they reject it or because they prove incapable of following
it, thus becoming, in the words of Subcommander Marcos, 'disposable'.[2] In
the second, it is a matter of promoting and stimulating those categories and
populations that confer maximum efficiency on the economic and techno-
scientific order according to the parameters of total acceleration. In other
words, selection discriminates and operates a division between those who
belong and those who do not belong in the future evolution of humanity.

Müller regarded Auschwitz as neither detour nor exception but rather
as an altar of capitalism, the final stage of the Enlightenment and a model
for technological society. The contentions are evidently controversial; we
would, however, do well to heed them because they focus on extreme and
hitherto unnoticed aspects of dominant social logic. Auschwitz is the altar of
capitalism because that is where man is sacrificed in the name of technological
progress, because the criterion of maximum rationality reduces man to
his value as raw material. The concentration camp is the final stage of the
Enlightenment because it is the full realisation of the calculus established by
it. Finally, Auschwitz is the model for technological society because, even in
death, industrial-scale extermination affirms the search for functionality and
efficiency, the fundamental principles of our modern technical system.

In this exemplary microcosm, Müller's characterisation of Auschwitz fuses

1. Heiner Müller, *Fautes d'Impression – Textes et entretiens*, tr. B. Umbrecht (Paris, L'Arche,
 1991), p. 189; originally published in German in *Transatlantik*, 1, 1989 (Berlin, Rotbuch
 Verlag, 1990).
2. See 'Correspondence with Subcommandante Marcos' in John Berger, *The Shape of a Pocket*
 (London, Bloomsbury, 2001) pp. 219-242 [Editor's note].

the celebration of a socioeconomic system with the final accomplishment of an epistemological field and the modus operandi of techno-science. In this sense, the camp updates and realises all the negative potential of modern Western civilisation through the basic criterion of selection, culminating in the obsolescence of man and his disappearance from the vector of technology.

<p style="text-align:center">***</p>

To read *The Lugano Report*[1] is to be reminded of Müller's comments. Susan George shows that the logic of extermination was not dissolved in 1945; on the contrary, it is now more current than ever, contriving neoliberal strategy even as it is implemented on a planetary scale. Abusive though such a comparison may seem, it is not. Müller knew that the Nazi strategy of total acceleration (both economic and techno-scientific) conformed to the principle of selectivity; George knows that neoliberal strategy rests on the same principle. Who has the right to belong to the future of humanity, and who is condemned to disappear? Both of them hate and oppose selectivity because it leads to genocide.

George perceives the genocidal nature implicit in the global strategy of neoliberalism. She realises that the current system is a universal machine for the destruction of the environment and for the production of losers; when she sought to put herself in the position of those who most profit from it, she discovered that they are restless. If she were as rich and powerful as they, thought George, she would need to have in-depth knowledge of projections regarding the evolution of the global system. It is, in fact, very likely that such analyses exist – although they would obviously never be made public. George then decided to write what she would need to know and conceived an ingenious literary resource. She imagined that certain unknown members of the global elite had commissioned a working group composed of specialists from all the fields of the human sciences, a secret study destined to define the strategic data that would enable the maintenance, development and reinforcement of the prevailing liberal capitalist market economy as well as

1. Susan George, *The Lugano Report: On Preserving Capitalism in the 21st Century* (London, Pluto Press, 1999); published in French as *Le Rapport Lugano*, tr. William Oliver Desmond, with the author's collaboration (Paris, Fayard, 2000).

the processes that the term 'globalisation' efficiently sums up. Gathered in Lugano, the working group would then have made its diagnosis on the eve of the millennium.

The invention of a secret commission is the only fictional element in this implacable assessment; the rest is documented by a mass of duly pondered data and presented in the cool, impartial language of the technocracy. The first part of *The Lugano Report* is devoted to the threats that weigh on the system, to the role of international institutions of control and the impact generated by the current explosive relationships between consumption, technology and population. Here are some of the working group's conclusions:

- The governors attempt to persuade the governed that a neoliberal economic order can include everyone everywhere, no matter how numerous, in the present and in the future. However, it is not remotely possible to integrate a world population of six to eight billion people.

- Before globalisation, economic processes were largely national and operated by addition. Today, precisely because they have become internationalised, they operate by subtraction. This has come to be known as 'downsizing' – the more costly human elements (labour costs) are eliminated, the greater the profit.

- Capitalist culture is characterised by competition and by creative destruction. Nowadays, however, those countries in which, for centuries, mercantile economy gave birth to a dominant capitalist culture make up less than 10 per cent of humanity. Such a percentage bodes ill for the future of the system.

- Given current demographics, bottom line conditions for the endurance and triumph of global capitalism cannot be met. One cannot simultaneously support capitalism and continue to tolerate the presence of millions of superfluous human beings.

- A smaller world population is the only way to guarantee the happiness and well-being of the majority. Difficult though such a choice might appear to be, it has been dictated by reason and by compassion. If we are to preserve the liberal system, there is no alternative.

The Lugano Report goes on to discuss the strategies by which to 'solve' the problem of the excluded by what Müller calls 'social cleansing'. But genocidal systems like that of the Holocaust are considered bad strategies. The authors believe that the Auschwitz model is the opposite of what we need today to

achieve the objective. In their view, the selection of the 'victims' should be the responsibility of no one but the 'victims' themselves: they will select themselves according to criteria of incompetence, of unfitness, of poverty, of ignorance, of laziness, of criminality and so forth; in short, they will find themselves in the losers' group.[1]

<p style="text-align:center">***</p>

Both Müller's and George's remarks on the logic of contemporary capitalism and its devastating effects seem most appropriate; they take us back to the beginning of this essay, back to the issues of belonging and *not* belonging as they appeared to a Third World intellectual as depicted in the art of Wall, Kabakov and Haacke.

The impressions resulting from such works allow us to consider belonging within the scope of the relationship between the citizen and the nation-state. But the crisis of the latter also carries with it the crisis of the former and, with it, the problem of belonging takes on another dimension; not belonging to the space of citizenship has come to signify not belonging to humanity itself, insofar as the selective principle established by the strategy of total economic acceleration has brought about criteria of inclusion and exclusion that condemn an important human group to no man's land.

Translated from the Portuguese by Stephen Berg

1. George, *The Lugano Report*, p. 123.

Where Here Is Elsewhere

Jean Fisher

The landscape of your word is the world's landscape.
But its frontier is open.
Edouard Glissant, *Poetics of Relation*[1]

The concept of 'belonging' presents a rather overwhelming set of questions and differing approaches. One might ask what belonging means in terms of how human beings inhabit their world. What are the material conditions of belonging? What does it mean not to belong, especially considering the material realities of peoples deprived of the means of being 'at home' in place, language or culture? In considering art, a further complexity arises concerning, on the one hand, where or how art belongs in the world and, on the other, the paradoxical nature of the creative process – that is, that the work takes place only in the creative self's loss of subjectivity to what Maurice Blanchot calls an 'essential solitude', an exile from the world.[2] How, then, to balance these approaches?

A critical debate is now taking place on the relationship of art to the sociopolitical sphere. Discussions on what is variously described as 'relational aesthetics'[3] or 'dialogical aesthetics'[4] are important insofar as

1. Edouard Glissant, *Poetics of Relation,* tr. Betsy Wing (Ann Arbor, University of Michigan Press, 1997), p. 33.
2. Maurice Blanchot, 'The Essential Solitude', in *The Space of Literature*, tr. Ann Smock (Lincoln and London, University of Nebraska Press, 1982), pp. 21–34.
3. Nicholas Bourriaud, *Relational Aesthetics*, tr. Simon Pleasance and Fronza Woods (Dijon, Les Presses du réel, 2002).
4. Grant Kester, 'Conversation Pieces: The Role of Dialogue in Socially-Engaged Art', *Theory in Contemporary Art since 1985*, ed. Zoya Kocur and Simon Leung (Oxford, Blackwell

there is a pressing need for a reconciliation of the aesthetic, the social and the ethical in ways that may at least form the conditions of possibility for a new concept of the political. To my mind, however, this issue is not first raised from the experience of technological revolutions or activist politics, but from the experience of cultural dislocation, in which relations are never equal, and the political is always already inscribed in the aesthetic. Since the seminal work of cultural critics such as Edward Said and Stuart Hall in the late 1970s, an impressive body of postcolonial commentary has shown that, for the diasporan subject dislocated from his or her place of origin and the indigenous person dispossessed by colonial occupation, hard-won citizenship rights often do not imply cultural belonging to national identity or the prevailing symbolic order; cultural identity is often imposed by forces outside the self, and the psychosocial dimensions of identification are fraught with ambivalence and contradiction. Roots are already rhizomatic and multilingual; the self is already doubly or even multiply inscribed with the other. 'Here' is also 'elsewhere'. It is therefore from the artistic practices of the dislocated subject that this commentary derives.

An 'unhomely' world?

There is a delicate balance between the human desire for security in roots and the desire for autonomy, especially when unjust rules and laws create 'unfreedom' and 'home' ceases to be 'homely'. Perhaps recognition of a malaise in the social sphere produced by the globalised world economy – with its utilitarianism, instrumental reason and dispiriting drive to commodify all aspects of life – underlies the increase in fundamentalisms ('foundationalisms' insofar as they seek to solve crises in nostalgic visions of past community) and the return in art to less individualistic and more collective concerns. One might ask, however, how far the meaning of belonging as 'possession', 'property' or 'attribute' (in English, 'belongings' signify 'private property') is still limited by the horizon of Cartesian subjectivism, whose legacy is the sacrifice of community and solidarity to an acquisitive, self-interested individualism. Does the West, with its citizenship and passport securely in its pocket, and capitalism's virtual territorialisation of every place, too

Publishing, 2004).

facilely speak of globalisation as the transcendence or dissolution of borders and determinate identities? The world is now hostage to a neoliberal (or neoconservative?) form of democracy that more than ever gives precedence to individualistic rights (of property) at the expense of collective welfare, aiming through the commodity system to establish a compliant citizenry. It has long been argued, however, that unrestrained capitalist accumulation only 'works' by simultaneously sustaining a vast disparity of wealth between the site of consumption and the site of production or, worse, by precluding certain sites from competing in the 'free' market system altogether. This economic differential is only one facet of a system of inclusion and exclusion that betrays its own democratic principles.[1] Such a neo-imperialist system is clearly not sustainable indefinitely, if only because the 'collateral damage' (to use one of its most popular military euphemisms) is the morally insupportable production worldwide of unprecedented numbers of 'noncitizens' – anonymously referred to as 'economic migrants', 'political refugees', 'asylum seekers', 'detainees', *sans papiers* – dislocated by war, poverty, disease and corporate ecological irresponsibility, unwelcome everywhere and excluded from all subjective, political, juridical and cultural representation. They are deprived not only of the right to 'belong', but also of the equal right *not* to 'belong'.

The grim histories of colonialism demonstrate that cultural dislocation through slavery and dispossession sets in motion a catastrophic mutilation of communal identities and social structures inherited by subsequent generations as cultural alienation and memory of terror and fear of its return, for which racial or ethnic violence are its ever-pregnant signs. Dispossession is *in extremis* a deprivation of the will to imagine new possibilities of existence. It also deprives the body and its labour of providing the means of dwelling securely in the world with a sense of future continuity. Thus, to dispossess a people is to reduce them to the brutal subexistence of the inhuman, an alienation not only of labour but also of spirit. What therefore is needed is a concept of belonging that does not slide easily into autistic subjectivism, individualistic possession and protectionist forms of territorialism, but that recuperates another more archaic meaning of proximity and unity capable of opening onto a more fluid, collective sense of being in the world with others

1. Article 2 of the Declaration of Human Rights states, 'Everyone is entitled to all the rights and freedoms set forth in this Declaration, without distinction of any kind, such as race, colour, sex, language, religion, political or other opinion, national or social origin, property, birth or other status.'

where words like 'welcome', 'hospitality', 'conviviality', 'sharing', 'caring', 'compassion' and 'empathy' might seem less alien.

To reclaim will and agency takes a supreme effort. It means forging one's way out of the impasse of traumatic victimhood, between remembering and forgetting, which demands, to borrow Michel de Certeau's phrase, a 'capture of speech' – an act of speaking which is not yet a statement, but a revelation of possibilities, the first tentative step towards a reconfiguration of self with world.[1] It is just this struggle that is so eloquently traced in Patrick Chamoiseau's novel *Texaco*, where Martinique's creolised former slaves strive to overcome the inertia of dispossession and to 're-found' their world. The narrator weeps in dismay 'upon seeing how old the storytellers were and how their voices, isolated from the world, seemed to sink into the earth like a carême rain after which I trotted in vain'.[2] He weeps at the dissolution of culture into autochthonous oblivion, a 'sinking' that can be rescued only by gathering up the remnants of existence into a new notion of dwelling. Thus, in retelling the founding of Texaco, City's *quartier* of creolised languages and indistinct boundaries, he assumes a witness's responsibility in the sense described by Édouard Glissant: 'Because historical time was stabilised in the void, the writer must contribute to restoring its tormented chronology, that is, to unveiling the fecund liveliness of a recommenced dialectic between Antillean nature and culture.'[3]

Texaco comes into existence as the concept of the Source, who is both oral storyteller and chronicler of history and it is she who reveals to her fractured neighbours the task of building homes in the face of the City authorities who would deny them this option. Thus building as founding and constructing is intimately linked to language. Here *Texaco* converges with the train of Heidegger's thought:

> Only if we are capable of dwelling, only then can we build ... The real plight of dwelling does not lie merely in a shortage of houses ... [but] that 'mortals ever search anew for the nature of dwelling, that they *must ever learn to dwell*'.[4]

1. Michel de Certeau, *The Capture of Speech and Other Political Writings*, tr. Tom Conley (Minneapolis and London, University of Minnesota Press, 1997), pp. 11–24.
2. Patrick Chamoiseau, *Texaco*, translated from the French and Creole by Rose-Myriam Réjouis and Val Vinokurov (New York, Vintage International, 1997), p. 389.
3. Glissant, *Poetics of Relation*., p. 385.
4. Martin Heiddegger, 'Building Dwelling Thinking', *Poetry, Language, Thought*, tr. Albert

Perhaps the Source, as the force that calls to and assembles these desolate souls bereft of origins into a commonality, features creolised language itself. If so, we may say that to be 'at home' is first to be at home in language, from which the meaning of existence – or a meaningful existence – is made possible. Language, however, does not exist in a void: whoever speaks also listens and responds to its appeal as an experience shared with others.

Heidegger took issue with the Western metaphysical tradition because it sought the meaning to existence outside the world. By contrast, he insisted that we can 'know' the world only through our engagement with it. Or, rather, 'world' is what, through our poetic intuitions, we are capable of disclosing or creating in relation to the ever-transforming, untotalisable and hence never entirely knowable totality of what is. In effect, every moment is the origin of a singular configuration of world, and there are as many 'worlds', or as many origins of 'world', as there are thoughts to bring them into being, not all of them mutually compatible, as we well know. Nonetheless, there remains the ontological question of what is human existence, or Being, beyond the contingent texture of the world and through which we might sense a common 'belonging', a 'commonality' that is not simply that of 'community', bounded as it is by the constraints of religion, ethnicity, ideology and so forth. However, Jean-Luc Nancy rebukes even the later work of Heidegger for not paying sufficient attention to the 'with' of Being. For Nancy, there is no Being that is not *a priori* 'being–with', 'being-in-common', where 'with' is constitutive of Being; hence there is no meaning if meaning is not shared.[1] The problem is how to hold on to one's own 'story', or singularity, whilst simultaneously understanding it as constituted in a common humanity.

Unsentimental journeys

James Joyce exiled himself from Dublin because he could find no place as a speaking subject under the conditions imposed by English colonial rule. His neologism 'dislocution' indicates the experience of dislocation in locution, that is, speech. Joyce sets the tone of betrayal, anguish and contradiction inherent in this experience in *A Portrait of the Artist as a Young Man*, where

Hofstadter (New York, Harper and Row, 1975), pp. 160–1.

1. Jean-Luc Nancy, *Being Singular Plural*, tr. Robert D. Richardson and Anne E. O'Byrne (Stanford University Press, 2000), pp. 1–99.

Stephen, during his exchange with the English dean of studies, thinks, 'The language in which we are speaking is his before it is mine. How different are the words *home*, *Christ*, *ale*, *master*, on his lips and on mine! I cannot speak or write these words without unrest of spirit ... My soul frets in the shadow of his language.'[1] Joyce eventually 'consoles' this 'unrest of spirit' by a violation of 'civilised' language itself: *Finnegans Wake* – his 'history of repression'[2] – is a mischievous subversion of English drawn through heteroglossia, Irish orality and the scriptovisual labyrinths of the Book of Kells. The weapon of repression – language – is turned against itself.

Despite his errantry in Europe, Joyce never ceased to write through the experience and reflections of 'home': 'For myself I always write about Dublin because if I can get to the heart of Dublin I can get to the heart of all the cities in the world. In the particular is contained the universal.'[3] For Joyce, belonging was indeed be-*longing*, a departure from which there was no hope of return, except through an ambivalent remembering, and in which writing was not to be the foundation of a new subjective ground for the writer, but, like Chamoiseau's *creolité*, a re-founding of language itself through the inchoate sounds of speech – a listening and a speaking.

Joyce lightens the burden of repressive language in the homelessness of 'two thinks at a time',[4] which is resonant in the work of Jimmie Durham. Durham, now multiply dislocated from his Cherokee origins, once said, 'One of the most terrible aspects of our situation today is none of us feel that we are authentic. We do not feel that we are real Indians. But each of us carries this "dark secret" in his heart, and we never speak about it ... For the most part we just feel guilty, and try to measure up to the white man's definition of ourselves.'[5] This was not, however, a position that Durham was content to inhabit. His *Self-Portrait* (1985) is a life-sized canvas cut out like a figure for target practice or a flayed skin. The body is inscribed with a doubled language – English and faux-Indian signs – and a doubled address – 'Hello, I'm Jimmie Durham ... Mr Durham has stated that ...' While the

1. James Joyce, *A Portrait of the Artist as a Young Man* (1916; London, Penguin Popular Classics, 1996), p. 215.
2. Seamus Deane, 'Introduction', in James Joyce, *Finnegans Wake* (1939; London, Penguin Books, 1992), p. xii.
3. Ibid., p. xix.
4. Ibid., p. 583.
5. Jimmie Durham, *Columbus Day: Poems, Stories and Drawings about American Indian Life and Death in the 1970s* (Minneapolis, West End Press, 1983).

work resembles its maker, it is not a representation of him, but a parodic mime of stereotypes of 'authentic' Indianness that reflect only our projections of identity; indeed, it undermines *any* claim to fixed or authentic identity: If *I* am not who you think I am, then neither are *you*. Durham was embarked on a journey committed to challenging those forms of totalising knowledge that distort the true nature of human dwelling. When asked recently about his voluntary and nomadic exile, Durham replied, 'It's my ambition in life to become a *homeless* orphan. I don't want to be at home', where, for him, 'home' means, among other things, 'secure knowledge', 'mastery', 'lack of doubt'.[1]

Willie Doherty is an artist who works in and against the 'unhomeliness' of home. His work was forged in the crucible of sectarian violence and British military occupation in Northern Ireland, a territory whose inhabitants have been traumatically divided by conflicting national narratives and too often dependent for their legitimacy on a mythologised 'foundational' past which, in obscuring the sociopolitical realities of the present, cripples the possibility of transforming the future. By contrast, Doherty's work addresses the dynamics of the present, especially how identity becomes fixed and encrypted in representations of place. It is through his interrogation of representation's claims to 'truth' that what began as a critique of the paralysing misrepresentation, stigmatisation and hence alienation of local community by news media and the state apparatus becomes a reflection upon a more universally felt incommensurability between lived experience and reality as it is constructed by the instrumental languages of power.

The instability of place understood as a 'home' but experienced as a space of uncertainty and transience is expressed through Doherty's *mises en scène*: those interstitial spaces in the city and its environs that have become, in the popular imagination, the sites of clandestine or violent acts – anonymous roadsides, dark alleys, derelict buildings and urban wastelands. Doherty's camera moves like a forensic eye over these opaque urban surfaces, mapping the detritus of a disquieting scene in which the viewer is also compelled to search for traces of meaning that might restore sense to an entropic collapse of order. In this body of work, the shadowy face of the everyday merges with the familiar 'noirish' elements of cinema where Everyman is caught in the impotent stasis of the nightmare. In accompanying 'interior monologues',

1. Jimmie Durham, in *Jimmie Durham* (Milan, Edizione Charta, 2004), pp. 123–5. Nancy, *Being Singular Plural*, p. 14.

the positions of self and other – or potential victim and perpetrator of violence – become ambivalently entangled. Most unnerving is *Non-Specific Threat* (2004), a 360-degree tracking shot around the head of a thuggish looking man standing in a derelict interior with lighting that renders the background strangely dislocated from the figure. The monologue is couched in the threatening but ambiguous language of fundamentalist violence – 'I am invisible ... I am unknowable ... There will be no water ... no electricity ... no TV ... no computers ... You create me ... I am beyond reason ... I am your victim ... I am your desires', and so forth – that unravels presumptions of determinate meaning. If the world is experienced as 'unhomely', it is partly due to the way we populate it with unseen and threatening 'others' that are ungraspable precisely because, in all likelihood, they are phantoms conjured by an increasingly paranoid public imagination fuelled by state interests and a complicit media.

Through tears and wounds

Doherty's work reminds us that to represent is to efface the thing represented whilst artfully producing the illusion that we possess it or have control of its meaning. This is to master otherness by turning it into the order of the same. Here we find ourselves caught in the contradiction between an instrumental language of power that coerces us into accepting its representations as or of reality and poetics as a play with the inherent indeterminacy of language and its potential to disrupt normative perspectives of the world. Thus, to lose sight of the poetic dimension of language and assume the transparent communicability of words and images typical of mass media is to conceal the fact that representation is an imaginary construction. It is precisely to forestall the rupture in meaning threatened by the unassimilable that representation installs our illusion of a coherent, autonomous subjectivity. How, however, might art enable us to pre-empt the objective knowing of representation and realise the empathetic understanding of what Nancy calls 'being singular plural'?

In contrast to instrumentalised visions of reality that prioritise information or the explanation of what is already apparent, one might take Nancy's (post-Heideggerian) view that art is a 'birth of a world', of a 'singular origin', where

origin means 'not from which the world comes, but the coming of each presence of the world, each time singular'.[1] Art represents 'nothing', but makes evident the presence of a hitherto unsaid, and perhaps unsayable, 'truth' that does not precede the singular event of art but arises from it. Thus, unlike representation, art does not affirm existing meanings, but as Adorno says of Beckett's plays, it 'puts meaning on trial'.[2] In this way, the viewing subject is disarmed of its certitude and compelled to negotiate with difference, its own and that of others.

Durham's *Not Lothar Baumgarten's Cherokee* (1990) is a modest work, on paper. It shows no more than the fragments of two juxtaposed scripts photocopied onto fine art paper: one is a few mutilated lines of Cherokee (torn from a copy of a letter written in the 1880s), the other is the artist's handwritten transcription of a text referring to Cherokees published in the Finnish language. Both texts are at the outer limit of linguistic familiarity and decipherablility, and we might imagine at first that their opacity signals an insistence on the untranslatability of difference in the face of the persistent attempt of the same to co-opt it.

Not Lothar Baumgarten's Cherokee was a riposte to the German artist Lothar Baumgarten's *The Tongue of the Cherokee* (1985–8), which seemed suspiciously to reflect a neoliberalist assumption of the right to 'speak for' the 'other'.[3] The work was installed in the Carnegie Museum of Art in Pittsburgh, where each letter of the Cherokee syllabary, elegantly engraved in glass, was isolated and trapped in the structural grid of the ceiling. Thus frozen like prehistoric flies in amber and divorced from their potential as writing (that is, their organisation into a thought), the letters (like indigenous peoples within the fantasmic imagination of white America) were removed to a non-historical past and an inaccessible, quasi-transcendental space (a reading somewhat exacerbated by a temporary floor installation by Alan McCollum which consisted of casts of dinosaur bones.) By contrast, Durham's work acknowledges the *material life* of language, albeit partially mutilated, standing

1. Nancy, *Being Singular Plural*, p. 14.
2. Theodor W. Adorno, *Aesthetic Theory*, tr. Robert Hullot-Kentor (London, Athlone Press, 1997), p. 153.
3. The complaint is not that a white man might speak out about the colonial depredations suffered by indigenous peoples – which Baumgarten does not do, but rather, appears to aesthetise the native sign – but that the white voice speaking of the indigenous is more palatable and credible to hegemonic culture than the indigenous voice itself. That is, the privileged voice *takes the place of* and thereby dispossesses the voice of the other.

metaphorically for the contemporary reality of indigenous peoples.

If we look again at *Not Lothar Baumgarten's Cherokee*, we find that what separates but also unites the two scripts is the diagonal tear of the paper; in an unsettling, sensual way, one is drawn irresistibly to the tear, not as an image but as an imagined *gesture*. It is a gesture that stages difference as a reciprocal movement between one writing and another. In this way, the work performs the relation between self and other as it is mediated through language. What appears to be 'communicated' is the pain of a communicability approached only through the incommunicable: the only certain relation to be established amongst us is the aporia of non-relation. 'Human beings', as Georges Bataille commented, 'are never united with each other except through tears and wounds.'[1]

In *7th November* (2001), Steve McQueen presents a large-scale slide projection, showing the shaved crown of a man's head bearing a wide scar, accompanied by a recorded narration. How the man came by the scar is not the subject of his story, but it is the focus of visual attention and a sign of what is engraved on his memory: the split second on the day when he became accidentally responsible for his brother's death. Woven through the narrative of this traumatic event are reflections on the act of telling itself, as the narrator appeals to the listener's understanding of his actions and feelings. His narration, in effect, is not about the event as such, but about self-transformation. The work induces an inexpressible anguish, deriving neither from the facts of the story, nor from what it might say about gun culture in the community. Rather, the teller's struggle to make sense of senselessness touches our *own* experience of a deeply felt aporia in human existence.

What is this aporia? Commentaries point out that the enormity of a human catastrophe is impossible for those who were not present to encompass in everyday experience except as a *void* of meaning, putting in crisis both representation and the authority of the survivors' testimony. One can only witness the absence of witness. As Giorgio Agamben notes, the aporia of 'Auschwitz' is the very aporia of historical knowledge: 'a non-coincidence between facts and truth, verification and comprehension'[2] – an impasse at whose heart lies the mutual silence between experience as lived and its

1. Denis Hollier, *Against Architecture: The Writings of Georges Bataille,* tr. Betsy Wing (Cambridge, MA, and London, MIT Press, 1992), pp. 67–8.
2. Giorgio Agamben, *Remnants of Auschwitz: The Witness and the Archive,* tr. Daniel Heller-Roazen (New York, Zone Books, 2002), p. 12.

inadequate representation. It is to this 'mutual silence' that McQueen's and Durham's work would seem to bear witness.

For Agamben, 'Auschwitz' produced a 'limit situation' in which the human crossed the threshold into the inhuman, exemplified by those prisoners described as 'walking corpses', whose extreme state of trauma left them incapable of experiencing or witnessing anything whatsoever, even death. This takes us back to the past and present conditions of dispossession. Like the 'walking corpses', the dispossessed self is rendered 'inhuman' insofar as it has been rendered speechless: it no longer dwells, and in this sense it cannot bear witness to its own subjectivity. Nonetheless, for Agamben, the *act* of testifying is essential, for it reveals what is at stake in being human – that the lack of speech is the implicit condition upon which the human founds a place from which to speak, from which to become a subject. As *Texaco* shows, writing as an act of witnessing is the visible trace of the transformation from non-sense to sense, impasse to passage, inhuman to speaking subject. Thus the art of the dislocated subject is never a representation of catastrophe, but a witnessing of this fragile passage between speaking and not being able to speak that is the shared 'solitude' of being and the common ground of humanity.

The play of the world

Heidegger took Western industrialised civilisation to task for having lost sight of the 'unity of the fourfold': earth, sky, divinities and mortals, each of which retains its own being while reflecting and gathering the others in a 'mirror-play of the world'.[1] He speaks of poetic creation as taking the measure of this entire dimension of existence, and if the West now dwells 'unpoetically' it may be the consequence of its succumbing to a 'curious excess of frantic measuring and calculating'.[2]

I conclude with two works that express this poetic 'measuring'. The first is Steve McQueen's installation *Once Upon a Time* (2003), which presents

1. Martin Heidegger, 'The Thing', *Poetry, Language, Thought*, pp. 178–80. Heidegger's 'unity of the fourfold' may be more 'at home' in Native American hermeneutics, where the 'four corners of the world' exist in mutual non-hierarchical relation, a 'symbolic writing' in which there can be no thought of an uninscribed 'wilderness'. This is common-sense, not mysticism.

2. Heidegger, 'Poetically Man Dwells ...', in *Poetry, Language, Thought.*, p. 228.

a free-hanging screen for image projection with a soundtrack. The 116 images are those launched into space by NASA in 1977 aboard the Voyager II space probe (presumably still hurtling through the universe) with the hope of communicating to life forms beyond our solar system what life on Earth is like. NASA's image sequence is constructed loosely around the human narrative of birth, life and death, but otherwise shows an idealised view of the worlds of nature and culture more reminiscent of old *National Geographic* magazines than any reality, from which all signs of religion, poverty, conflict and disease have been expunged. Although patently lacking 'truth', the slow fading in and out of these estranged images is hypnotic and emotional in its effect, invoking the pathos of human desire's betrayal by representation. Like the image sequence, the soundtrack also speaks of the desire for communication with the quasi-divine nonhuman. It is of voices 'speaking in tongues', a glossolalia commonly associated with Pentecostal churches and thought to express communication with the spirit world, or 'angels'. On one level, then, the work may be read as a critique of the absurd strivings of religious metaphysics.

Curiously, however, a rhythmic poetics emerges from the repetitive incantation of vocables; it is as if it *were* language despite its indecipherability, such that, like Durham's *Not Lothar Baumgarten's Cherokee*, it conveys communicability without communication, 'truth' in its very absence of truth. Like the angel, Voyager is a 'messenger' whose message is that what mediates between the human and the inhuman is language. Listening through rhythm and breath, breath as 'spirit' or the 'presencing' of being beyond any thought of a subject, are consistent elements in McQueen's recent work. They are the kind of 'measuring' of which Heidegger speaks, now implicitly drawn in *Once Upon a Time* as the distance between human and alien or angel – measuring not as quantification, but as an intuition of the entire dimension of human existence between 'earth' and 'universe', the finite and the infinite, the knowable and the unknowable.

In a recent collaborative work, *Cuando la fe mueve montañas* ('When Faith Moves Mountains') (April 2002), Francis Alÿs assembled 500 volunteers using shovels to displace by some 10 centimetres a 500-metre-long sand dune overlooking Ventanilla, a *pueblo joven* (shantytown) on the barren outskirts of Lima.[1] The project asked what can be the relevance of a poetic act in the

1. In collaboration with the Mexican art critic Cuauhtémoc Medina and film-maker Rafael

context of sustained political and economic crisis in countries like Peru, where the dislocation of people and the coming into being of Ventanilla and other towns like it is but one of its consequences – a symptom in fact of a fundamental void of meaning in the structure of polity to which the entire play on displacement in the work alludes? Few commentators would dispute that on the face of it, *Cuando la fe mueve montañas* was a ludic, if not ludicrous, gesture. A huge deployment of voluntary labour with nothing ultimately to show for it – on site, at least – except some tracks in the sand, sooner or later to be obscured by the forces of wind and gravity. Like McQueen's *Once Upon a Time*, it lays bare the Sisyphean absurdity of the human condition, caught between utopian aspiration and frail endeavour in the larger space–time schema of the world. Its very play of grounded and groundlessness, materiality and immateriality conjures up that abyssal gap between the burden of everyday existence and the weightlessness of the imagination, where the sheer gravity of existence in most regions of the world lends art at times an air of the frivolous. What eventually emerges as ludicrous and meaningless, however, is not Alÿs's poetic gesture, but what it discloses of the geopolitical context that frames it. It is precisely at this moment of disclosure – when habitual structures of reality are shown to no longer make sense – that one can rethink the aesthetic, the ethical and the political as not inherently irreconcilable categories of experience, but the intimate conditions of human dwelling. Alÿs's imagination mobilises space, human labour, a spiritually liberating thought, and sand – an organically inert material that provides little sustenance for life, but which is nonetheless a basic ingredient for building foundations, that is, culture. Thus, the allegorical meaning of the work is clear: through poetic thought, the human can re-imagine and reconfigure its being in the world.

Although this work is tied into the economic structures of the art world, it nonetheless engages elements of what Certeau calls a 'subterranean economy', deemed worthless by the forces of commodification but decisive for the survival of human exchange[1] – hospitality, exchange of non-remunerative services, barter, oral dissemination and fabulations that enter the collective imagination to link diverse constituencies. The imaginative freedom released

Ortega, the use of shovels and manual labour reflects the poverty of the 'Third World' and would seem to be a pointed reminder of the tendency in US land art of the 1970s to use expensive earth-moving machines.

1. Certeau, *Capture of Speech*, p. 93.

by such artistic practices provides the conditions of possibility for a nascent political consciousness, where the political may be understood not simply as political discourse or the structures of power and the state, but as what grounds being-in-common in the separation and intimacy of world and thing. The threshold between separation and intimacy is pain – the rift that 'tears asunder, it separates, yet so that at the same time, it draws everything to itself, gathers it to itself'.[1] As Chamoiseau narrates, every Texaco – or Ventanilla – needs its myths and storytellers on which to found its belonging, but belonging is, as Heidegger states, 'kindness' – kinship and affection: to 'dwell poetically' is to 'keep kindness with our hearts'.[2] From this standpoint, art's origin and destiny no longer lie in the movement from and to an autonomous self, but in sustaining a poetic imagination capable of disclosing the ethos or common dwelling place of our humanity.

1. Heidegger, 'Language', in *Poetry, Language, Thought*, p. 204.
2. Heidegger, 'Poetically Man Dwells', pp. 228–9.

In Defence of Metaphor

Elias Khoury

Al-Khalil ibn Ahmad al-Farahidi of Basra, the eighth-century founder of classical Arabic prosody, once said:

> Poets are masters of speech, conjugating it as they will. What is allowed them is denied others. They free meaning or they fetter it. They obfuscate an utterance or they clarify it. They elaborate the condensed and they condense the unabridged. They combine different articulations of a meaning and they distinguish between its attributes, thus extracting what tongues have tired in trying to describe and label and what minds have wearied of trying to comprehend and illuminate. They make what is near distant and what is distant near. Their arguments are used to confute but cannot be refuted. They depict the fallacious in the image of the veracious and the veracious in the image of the fallacious.[1]

In his description of poets, al-Farahidi proferred a description of art's essence in his time. Poetry in classical Arab culture was not merely the supreme art; it also combined all the arts in one. The poet was seen as a musician, a painter and an image-maker. Further, he imparted knowledge of human affairs and summed it up. Above all, the poet was viewed as a breed apart whose difference stems from the nature of the poetic vocation. In this view, the poet does not write alone; rather, he has a *jinni* or a muse for a partner – the Arabs call it 'the companion' – who dictates the verse. In the light of

1. Cited in Muhammad Lutfi al-Yusufi, *Al-Shi'r wa-l Shi'riyya: al-Falasifa wa-l-Mufakkirun al-'Arab wa ma Anjazuh wa ma Hafu Ilaih* (Poetry and poetics: Arab philosophers and thinkers: their fancies and accomplishements. (Tunis, al-Dar al-'Arabiyya lil-Kitab, 1992).

this companionship, the poet was viewed as a mediator between two worlds, the visible and the invisible. Poetry thus is the material embodiment of two distant worlds that are not conjoined save through the bond between music and meaning and through the image that only metaphor can create.

The metaphorical image raises a crucial question, for the fusion of rhythm and meaning leads to another question about the meaning's meaning, that is, the internal relations, which reformulate meanings, depict their frame of signification, and create images of reality and of the relationships that exist within it. Yet how do we read relationships within these recondite worlds? If the poet's *jinni* has vanished, how then does the critical reading illuminate the world of creativity and extract its connotations? The pertinence of these questions derives from the fact that postmodernist art represents itself as rewriting or reinterpretation of art that preceded it, that is, writing about writing and interpreting interpretation. Postmodernist works thus emerge as a cluster of questions not only about *things* but also about their fundamental *images* in art and various forms of expression.

Perhaps the *jinni* emerges from absence or exile from a place, as though the pre-Islamic poet when he opened his ode by standing on the deserted encampment was summoning absence and conversing with exile. The deserted place resembled the obliterated tattoo on the hand, as in the opening of the pre-Islamic, classical ode by Tarfah ibn al-'Abd. The abandoned place was an obliterated writing that the poet worked to re-inscribe. The poet read what was erased with longing for the demolished place. The sense of exile and longing for the remains of a place travelled beyond pre-Islamic poetry: it touched the literary experience as a whole. Exile and longing became a grand attribute, for example, of the imaginary in the book of *The Thousand and One Nights.*

Sinbad went into exile in order to return to his homeland laden with stories. The prerequisite for telling stories is a departure followed by a return. Leaving and exile stand as the conditions of knowledge and discovery. Return is the condition of writing or gathering that renders the strange familiar. The word for 'writing' in Arabic derives from 'gathering'; the writer gathers what has been dispersed and reshapes it.[1] He therefore has to return to the place that launched him. In this lies the essence of Sinbad's play throughout

1. Unlike the verb *kataba* (to write) and its derivatives, the verb *allafa*, literally meaning 'to gather' implies 'writing' [Editor's note].

his sojourns: return or at least dreaming of it. Yet what if return becomes impossible? What if the hero-narrator perishes in his exile? Who will tell his story and why? Was not that the hero's fate in Conrad's novel *Amy Foster*, where Yanko, who was emitted by sea waves, lives the tragedy of exile and suffers the defects it inflicts on body and soul?

Contemporary literary experience fascinatingly draws on this consciousness – from Conrad's stranger who was exiled into *The Heart of Darkness*, a product of the colonial era, to Edward Said, who was forced by the débâcle of Palestine to live *Out of Place*. Does living out of place create a world of darkness and shadows for the artist to inhabit so that his irreversible journey becomes an embodiment of human suffering and an endeavour to fill the void with voices, images, and words?

Jean Genet saw a potential conversation between the living and the dead in Giacamotti's sculptures, ones which 'dazzle the dead'. But the writer, who was a thief, a prisoner and vagabond, made of his life an incessant journey. He chose to board in Parisian hotels rather than to have a house of his own. He chose to be buried in Morocco, only to be buried in the cemetery of outsiders.

Genet's choice of exile endeared him to Algerians, Blacks and Palestinians. From *The Screens* to *Prisoner of Love*, writing became his life. For him writing obliterated differences between things and their images. The suicidal rebellion of *The Maids* became a manifestation of the impossibility of symbiosis between oppression and the feeling of degradation on the one hand and the human being on the other. Genet went into exile in order not to return. Thus he identified with the banished and the exiled. This choice was not merely the result of the marginal life he faced since his orphaned childhood; it had to do with the kind of life and art he opted for. Genet rejected the notion of transcendental art. He admitted that writing was his ruse to leave the prison. Knavery joins another of the French author's cherished suppositions: we have to lie in order to speak the truth. Lying reminds us of another notion in classical Arabic poetry formulated by critics as 'the most quenching of poetry is the most deceitful', whereby deceit becomes a synonym for metaphor and other tropes. It is as if reaching for the truth of things presumes finding forms of expressions that deviate from it. This leads to fascination with equivocal expression. However, knavery does not take us back only to *The Thousand and One Nights* whose modus operandi hinged on narration as a ruse in the

face of death, and on speech and knowledge as remedies for the insanity of envy and zealousness of power. Knavery takes us back also to a narrative structure stretching from the tenth-century genre of rhyming prose known as *al-maqamat*, whose pedantic goals and linguistic vitiation turned narration into a linguistic ornament, up to the folkloric and satirical anecdotes of Juha in their fusion of knavery and bitter humour.

The hero uses cunning with life through narration; description of things is done within a basic context that constitutes a defence of life itself. When oppressive authority sponsors murder, writing inevitably becomes a blank book written in venomous ink as in the story of King Yunan and Duban the sage, who presents the former with a poisoned book, as a gift, to avenge his beheading. This notion is borrowed by Umberto Eco in *The Name of the Rose* from *The Thousand and One Nights,* where Scheherazade's struggle with authority is used as a metaphor for the narrator's ability to kill in defence of his own life. In this sense metaphor stands not simply as an artistic image, but also as a means for struggle. Based on the Aristotelian notion that establishes description and mimesis of things on their action and motion, not on their stillness, metaphor becomes a tragic simulation of action, not things. Metaphor relinquishes its rhetorical task for the sake of viable action. The author of the poisoned book narrates only in order to threaten and uses metonymy only to create a direct impact on the listener. The play with ink and venom is revealed through the head of the sage which utters the murderous truth at the moment of its wrongful beheading by the monarch. This is the reprisal that Knowledge exacts from Power, when the latter appoints itself as the proprietor of people's lives.

In this complex and allusive game lies a secret characteristic of artistic and literary expression. Art conjoins various kinds of human experience in the struggle of the authority of knowledge against the authority of power. Narrative, like the art of Arabic calligraphy and arabesque patterns, becomes a willful creation of mirrors opposite each other. And language becomes a form of resistance against power and against annihilation. The eighth-century Ibn al-Muqaffa' of Basra offers such an interpretation in *Kalila and Dimna.* These metaphorical tales whose protagonists are animals are multifarious; structurally, they resemble a snare. As with cracking a walnut, the reader has to crack the outer shell of the text in order to reach the kernel and to taste the meaning behind the meaning.

But how is this hidden meaning determined? Perhaps the answer lies in viewing reading as an act of recomposition and creativity as redrawing on a drawing or reading of a reading. Here we revisit the fundamental question posed by the quest for knowledge and its relation to place, as in the case of Sinbad. For Sinbad the question is not meaningful, because he is ordained to return to the place where he began in order to tell his dazzling story. This question, however, acquires a perplexity of meaning and significance in the so-called era of postmodernism, where the return to an original place evokes troublesome questions. What is the meaning of an original place? Whose authority presides over it? Is a return to it possible?

If we revisit the twentieth century, historical consciousness reveals to us the magnitude of the calamities inflicted and how they cast their shadow on the beginnings of the twenty-first century. The twentieth century began with the massacres of the First World War and ended with Bosnian massacres and the war in Iraq. Between these events, there rolls a rapid chain of catastrophes: from the Nazi holocaust to the atomic bombs in Japan, and from the Russian Gulag to the Palestinian tragedy, a sequence of man-made horrors whereby the world emerges as a cluster of migrations, exiles and prisons. One only need read the dark record of Latin American dictatorships or ponder prison literature in Arabic in order to discover that tragic consciousness overwhelms historical consciousness and to realise that the world today is no less barbaric than the world of the Mongols, the Crusaders and the Conquistadors. In a world bearing such consciousness of tragedy, a literary genre was born, named by George Steiner 'exilic literature'. Steiner states: 'it seems proper that those who create art in a civilization of quasi-barbarism, which has made so many homeless, should themselves be poets unhoused and wanderers across language. Eccentric, aloof, nostalgic, deliberately untimely'.[1]

Exile and loss of homeland are not the mark only of migration or expulsion from one's country; they can also indicate an internal exile, the severest of all exiles. Did not the Palestinian poet Rashed Hussein turn into a destitute in his own country of birth after it lost its name and identity and before despair led him to his death by the ashes of his cigarette in his small New York flat? Meanwhile, the eminent Palestinian poet, Mahmud Darwish, lives on as a refugee in his homeland and adheres to language and narration, because

1. Quoted in Edward Said, *Reflections on Exile* (Cambridge, Harvard University Press, 2002), p. 174.

'language is bequeathed like land' as he writes in one of his poems. Becoming a Native American (as in the poetry of Etel Adnan), turning stories into a Palestinian metaphor (as in Darwish's collection *Eleven Planets*), painting tragedy in the iconic manner of Paul Guiragossian, borrowing Arabic calligraphy as a mask to envelop exile with sequences of meaning in search of meaning (as in the works of Kamal Boullata), seeking another body inside the body (as in the installations of Mona Hatoum) – all are forms of expression that the exiled judiciously selects in order to bamboozle life with life. Is this not the main lesson of the journey towards insanity that the fictitious character of Sa'id , the ill-fated 'pessoptimist', presents in the novel by Emile Habibi, who is a Palestinian citizen of Israel, and does not Habibi's journey cross with that of his compatriot, Anton Shammas, who searches for his other self in order to compose *Arabesque*?

These experiences of exile are remarkable because they abandon cultural symbol for the sake of transforming the human condition into a symbol of another condition. The new calamity rests on the one that preceded it. The reference is neither literary nor cultural. Metaphor is forged in a direct bond with memory and actual living. It lends itself to another story like it, so its experience could become more than an expression, so it could erase the distance between the lived condition and its expression. As in the story of the venomous white book, art becomes not only an embodiment of its reality and suffering, but *a form* of resistance against exile.

This resistance against exile establishes a new place for belonging. It also establishes George Lucas's transcendental vagrant. The condition of the exiled and the marginal converge into a new rhythm, making homelands out of words and images. This creation enables us to articulate a cultural globalisation, which contests its dominant counterpart. The articulation entails the search for new values created by dream and longing. Nothing seems harsher than the loss of homeland and the suffering of refugees as when identity becomes an indictment and when the natural belonging to a nation, language or religion becomes a cause of suffering. The concealed justness of the Palestinian cause expresses the condition created by silencing the victim and by distorting the relation between the victim and his executioner. Today, the Palestinian belongs to many worlds: he is a refugee, expelled from his homeland to live in shanty towns called refugee camps. He may live in Europe or America, where he creates a bond with a name that has lost its object. He

may also live as a citizen-refugee in his homeland, after the homeland has lost its name; that citizen is then sentenced to accept the disappearance of his national identity because instead of being Palestinian he has to become Arab in the 'Land of Israel'. Last, he is a resident of the 'territories', meaning the West Bank and Gaza, where he faces occupation, settlements, the wall and checkpoints and is then called a 'terrorist'.

Contemplating the current reality of the Palestinian compels us to ask questions about what belonging really means. What characterises Palestinians is not the injustice they suffer, but their deprivation from expressing it: first by concealing the name, then by transforming a previous victim into an executioner, and last by having the world turn a blind eye and blaming the victim. All make the declaration of belonging to Palestinian torments a moral duty in contemporary culture.

Palestinian belonging entails the right to declare the truth, and the right to search for a relative justice that would enable those wronged to own their narrative and to identify with their name, to demand that their oppressors admit their guilt when in 1948 an entire people was expelled from its homeland in their name. For these victims, belonging and telling their story in order to describe their suffering differs radically from the expression of belonging created by racial, sectarian or religious zeal that prevails in the era of American global hegemony. Moreover, problems of belonging can intersect. After the tragic events of September 11 and the rise of fundamentalism in its two ugly faces – factional terrorism and neocolonialist wars – 'belonging' as a word became predicated on an ideology entailing the rejection or humiliation of the other. The notion of war between religions and civilisations pervades the globe in such a way that it seeks to make the world regress to a second medieval era, ruled by inquisitions.

The notion of belonging that I seek to articulate stands opposite racial and religious purity. I seek belonging to a place, not to an idea or doctrine. Distance from that place does not necessarily preclude reaching it. Nor will residing in it pre-empt the sense of internal exile. Belonging, as I see it, is a multifaceted relationship. It opens horizons of belonging to the human endeavour whose facets are revealed by expressing the forms and possibilities of human existence.

Exilic literature from Auerbach to Adorno, from Joyce to Benjamin, reveals the depth of human resistance against barbarism. In the twentieth

century barbarism took the form of an extremist, nationalist call; at the start of the twenty-first century, it takes the form of a call for constant war, murder and destruction under the pretext of defending identity or in the context of erecting ramparts to surround the New Atlantic Rome.

The belonging I write about emerges as liberation from the sway of a place; it is a belonging to people *in* places. The place in and of itself lacks meaning. The human names the place and calls it a homeland or simply home. The delirium of a mythical place that wrought massacres in Kosovo resembles only the hysteria of the religious place that vindicates settlements and occupation and establishes apartheid in Palestine.

Contemporary artists and authors resemble Sinbad in his quest for a journey, vagrancy and exploration. Their tools and meanings migrate between places and languages. They also resemble him by belonging to a world of diverse languages and ethnicities. But they differ from him in that they lack the certainty that he enjoyed. Sinbad was the son of a culture whose values were ingrained and backed by a firmly established state, and therefore, he had a strong sense of the place. The artists and writers of our times do not return to a place of stable values and forms. Their very being is afflicted by a crisis, searching for significance in the only reference available to them, namely, in the very artistic forms they create. This means that the return to the place of belonging, when possible, plays only a minor part in exciting the longing of the artist. Unlike Sinbad, contemporary artists and authors have to extract stability from motion, meaning from resistance to homogeneity, and find values by diving into the depth of the human struggle against tyranny.

The question that torments me in the story of the white poisoned book did not torment Scheherazade who told stories under the spectre of sex and death. She found in the whiteness of pages a metaphor for the demise of power when it loses all logic and plunges into destroying knowledge. My question arises from the possibility of a world where metaphor is absent. The most eloquent description of tyranny, collective extermination and ethnic cleansing reveals the fact that they are pursued in a world lacking metaphor, where *the word* returns to be *a wound*, as its Arabic philological root indicates. A world without metaphor is a singularly criminal world – merciless, unfeeling and alienating. In such a world, the white book ceases to be useful, and so is the use of other symbolic poison. Hence art and literature embark on a feverish quest to fill the void with imagery and tropes. They seek, in other words, to

save language from death and expression from extinction.

Creative interpretation regains its power to affirm the right of human bonding and the right to pursue human diversity through its struggle against authoritarian linguistic monism and against literality. This pursuit manifests itself in the passion for creating different images of a world we must rediscover daily. In the endeavour of each poem, painting, installation or novel to forge new forms, to deconstruct the hegemonic image, to insist on the right of metaphor, we are born anew.

In his depiction of the poet as an artist, al-Khalil ibn Ahmad al-Farahidi spoke only of linguistic diversity in the face of a singularly domineering language. Familiarising the distant and distancing the familiar are but possibilities of metaphor, which create a multiplicity of vision and potentialities of meaning. This is how art creates its vision and a space for itself made of words and images. This is also how art creates a place and gives to whoever belongs to it the meaning of liberty.

Translated from the Arabic by Khaled Furani

Spheres, Cities, Transitions:
International Perspectives on Art and Culture

Gerardo Mosquera

The Sphere, a 15-foot, 45,000-pound steel and bronze sculpture by Fritz Koenig, used to be simply one more public art piece standing in front of a skyscraper, only that it was placed at the World Trade Center plaza 'as a monument to fostering peace through world trade'.[1] It suffered considerable damage by the September 11 terrorist attack. On 11 March 2002, the ruined sculpture was re-installed at Battery Park, close to its original location at Ground Zero, to serve as a memorial, its initial meaning drastically transformed by events.

A sculpture in the shape of a sphere is, in a certain way, related to minimalism, concretism and geometric abstraction. It is highly telling that the link of this particular sphere to September 11 contradicts the canonic interpretations of those artistic tendencies that represent paradigms of certain mainstream directions in art today. Beyond their initial aim of creating art as 'a new reality', taking it away from representational functions (a utopian project that was never fully accomplished), they have been used to create an extremely introspective concentration of art on art itself. The excess of self-referentiality, repetition and minimalisation in the use of real time and of almost imperceptible gestures, has flattened much artistic production, jeopardising its possibilities for creating meaning and thus, what is even worse, making them terribly boring. I am not saying that it is worthless for art to focus on itself; I am referring to a comfortable worthlessness and an

1. Elissa Gootman, 'A quiet and understated ceremony punctuated by two moments of silence', *The New York Times*, 11 March 2002, p. A-13.

arrogant self-isolation characteristic of certain contemporary inclinations in the art scene.

The sphere is the ultimate *gute Form*, a basic shape of perfection. It also expresses the idea of wholeness, referring to the world, or rather to the Renaissance's newly acquired capacity of representing the entire planet by means of a globe, thus transcending medieval conceptions that depicted it as a flat surface full of uncertainties, abysses and dragons. The very acceptance of the roundness of the Earth implied the possibility of global navigation and domination and the reduction of the world to a sphere closed in upon itself. Scientific knowledge helped reduce all kinds of enigmas, dangers and complexities to a dragon-free icon of a world-in-the-hand that could be touched, held and controlled (as represented in statues of Christopher Columbus) or even played with, as Charlie Chaplin does in *The Great Dictator*.

Travelling through Portugal, one is struck by the large number of monuments that include globes made of rock or bronze or as a recurring decorative Renaissance and Baroque element. At times we see a great globe on a pedestal: the monument commemorates the very capacity to travel through, know, use and dominate a world synthesised in a geometric figure. This shows us that the idea of globalisation already appears symbolically in European imagery at the beginning of the sixteenth century.

In the twenty-first century the dragons have returned. The sphere has been violently destroyed, and a new icon has not replaced it. Its ruins were put back on the pedestal, as a symbol of the sphere's own blatant pretension to sum up and grab the world. Is this post-sphere an icon for postglobalisation? In any case, the sculpture's pristine, detached, self-contained character has been brutally violated. The much-mentioned gap between art and life has been overcome in a most unexpected way, by the formal and conceptual transformation of an artwork, as a result of its invasion by harsh reality. This invasion was a real attack, which forced new content into the piece.

Contemporary art is being affected, to a considerable extent, by lack of meaning, by extreme professionalism ('smart-art-scene' production, marketing of works skillfully executed to fit demands and expectations, and so forth), by flat cosmopolitanism or by repetition and boredom, among other problems. But at the same time we are going through a fascinating period of

transition and reshaping of the whole system of art creation, distribution and evaluation at a global scale. Even if this process is happening slowly and in a 'silent' way, it is unprecedented in its scope.

Regional and international art circulation has dramatically expanded through a variety of spaces, events, circuits and electronic communications. Many of them have propitiated some of the problems just mentioned. A good example is the proliferation of unfocused small biennials all over the world, or the spectacle-oriented, mall-like big ones. The art biennial is the amazing case of a nineteenth-century institution that is not only still alive, but blooming all over the world. This institution is part of a cosmopolitan, apologetic, exhibitionist and mainly commercial spirit. In artistic and cultural terms biennials are often considered a failure, mainly in connection with their ambitious scale, their cost and the invested effort. This seems not to worry their organisers, who continue repeating the outline or inaugurating new biennials under the same design. In fact, the artistic and cultural outcome is usually more the excuse than the true objective behind the complex plot of interests and actions that must be mobilised to undertake such an immense and difficult venture.

Simultaneously, with the dramatic expansion of international art networks, there is new energy and activity going on locally in areas where, for historical, economic and social reasons, one would not expect to see interesting art. Working in such places as Central America, India, Palestine and Paraguay made me witness not only vigorous and plausible artistic practices, but also the foundation of alternative spaces and a notable array of anti- or non-establishment actions.

Much of this activity is 'local': the result of artists' personal and subjective reactions to their contexts or the consequence of their intention to make an impact – cultural, social or even political – in their milieus. But these artists are frequently well informed about other contexts and mainstream art or are also looking for an international projection. Sometimes they move in, out and about local, regional and global spaces. Usually their art is not anchored in nationalistic modernism or traditional languages even when based on vernacular culture or specific backgrounds. Even in the midst of war, as in Palestine, one discovers engaging works that challenge our preconceptions and ratify to what extent artistic dynamics are increasingly decentralised.

In addition, more and more new cultural and artistic agents have been

appearing in the newly expanded international art scene. No doubt, the fact that a certain number of artists coming from every corner of the world are now exhibiting internationally only means, in itself, a (not so radical) quantitative internationalisation. But number is not the issue. The question for these new subjects is agency: the challenge of mutating a restrictive and hegemonic situation towards active and enriching plurality, instead of being digested by mainstream or non-mainstream establishments. It is necessary to cut the global pie not only with a variety of knives, but also with a variety of hands, and then to share it accordingly.

In a process full of contradictions, new generations of artists are beginning to transform the status quo. They are doing so without manifestos or conscious agendas, creating refreshing work, introducing new issues and meanings that come out of their diverse experiences, and infiltrating their cultural difference in broader, somewhat more truly globalised art circuits. Naturally, this is not a smooth path, and many challenges and contradictions remain. Is the situation becoming richer and more complex, or is it being simplified by a degree of standardisation that a transcultural, international communication requires? Are the differences being communicated and negotiated or just converted into a self-complacent taxonomy? Who exerts the cultural decisions,[1] and for whose benefit are they taken?

A crucial tendency is the internal broadening of the so-called international art and art language through the intervention of a multiplicity of actors. If still instituted by mainstream orientations to an ample extent, this language is being increasingly modified and actively constructed by artists from the 'peripheries'. This is crucially important because controlling language also conveys the power to control meaning. Therefore, more than a mosaic of multiple artistic expressions, what tends to prevail is a diversified construction of an 'international art' by diverse subjects from diverse locations. This tendency for diversification opens a different perspective that opposes the clichés of a 'universal' art in the centres, derivative expressions in the peripheries, and the multiple, 'authentic' realm of 'otherness' in traditional

1. See Guillermo Bonfil Batalla, 'Lo propio y lo ajeno: Una aproximación al problema del control cultural', in *La cultura popular*, ed. Adolfo Colombres (Mexico City, Premiá, 1987), pp. 79–86, and 'La teoría del control cultural en el estudio de procesos étnicos', *Anuario Antropológico*, no. 86, 1988, pp. 13–53. See also Ticio Escobar, 'Issues in popular art', in *Beyond the Fantastic: Contemporary Art Criticism from Latin America*, ed. Gerardo Mosquera (London, INIVA and MIT Press, 1995), pp. 9–113.

culture. Obviously, the very notion of centre and periphery has been strongly contested in these porous times of migrations, communications, transcultural chemistries and rearticulations of power.

In all corners of the planet we are witnessing signs of change in the epistemological ground of contemporary artistic discourses based not *in* difference but *from* difference. This transition could be epitomised as the gradual turn of direction in cultural processes that used to go mainly from the 'global' to the 'local' and from the 'local' to itself. In this sense, notions of hybridity and 'anthropophagy' are beginning to be surpassed. I will briefly discuss the last, which has been very influential in Latin America.

Brazilian modernists used the figure of *antropofagia*[1] (anthropophagy) in order to legitimate their critical apprehension of European artistic and cultural elements, a procedure peculiar to postcolonial culture in general. *Antropofagia* is not only a cultural strategy but also a metaphor for the tendency to creatively appropriate alien cultural elements, which have been present in Latin America since the early days of European colonisation. The very multisyncretic character of Latin American culture facilitates this operation, because it turns out that the elements embraced are not totally alien. In a sense, Latin America is the epitome of these processes, given its problematic relationship of identity-difference with the West and its centres, by virtue of the specificity of its colonial history. Our consanguinity with hegemonic Western culture has been at the same time close (we are the 'common-law offspring' of this cultural lineage) and distant (we are also the hybrid, poor and subordinate offspring). The practice of *antropofagia* has enabled us to enact and enhance our complexities and contradictions. Only Japan outdoes Latin America as transcultural cannibal.

Latin American anthropologists and critics have emphasised the creative and subversive aspects of these strategies of re-signification, transformation and syncretism and how they became a paradoxical manner of constructing difference and identity. 'Cannibals' are not passive by definition: they always transform, resignify and employ according to their visions and interests. Appropriation, and especially one that is 'incorrect', is usually a process of originality, understood as a new creation of meaning. The peripheries, because of their location on the maps of economic, political, cultural

1. The term was coined by Brazilian writer Oswald de Andrade in his *Manifesto Antropofágico*, published in 1928.

and symbolic power, have developed a 'culture of resignification'[1] out of the repertoires imposed by the centres. It is a transgressive strategy from positions of dependence. Besides confiscating for one's own use, it functions by questioning the canons and authority of central paradigms. According to Nelly Richard, the authoritarian and colonising premises are in this way de-adjusted, re-elaborating meanings, 'deforming the original (and therefore, questioning the dogma of its perfection), trafficking in reproductions and de-generating versions in the parodic trance of the copy'.[2] It is not only a question of a dismantling of totalisations in a postmodern spirit; it also carries an anti-Eurocentric deconstruction of the self-reference of dominant models[3] and, more generally, of all cultural models.

However, *antropofagia* as a programme is not as fluid as it seems, because it is not carried on in neutral territory but one that is subdued, with a praxis that tacitly assumes the contradictions of dependence and the postcolonial situation. Thus, the tension of who eats whom is always present. Latin American artists have complicated, to the extreme, the implications enveloped in transcultural quotation and seizure. Some, like Juan Dávila and Flavio Garciandía, dedicate their works to cynically exploring such implications.

Another problem is that the flow cannot always be in the same north–south direction, as the power structure commands. Regardless of how plausible the appropriating and transcultural strategies are, they imply a rebound action that reproduces the hegemonic structure, even when contesting it and taking advantage of its possibilities. It is necessary as well to invert the current – not by reversing a binary scheme of transference, challenging its power, but for the sake of enriching and transforming the existing situation. A horizontal volley would also be welcome, one that could promote a truly global network of interactions towards all sides.

Today, the *antropofagia* paradigm is increasingly being displaced by what we could call the '*from here*' paradigm. Rather than critically devouring the international culture imposed by the West, artists from around the world are actively producing their plural versions of that culture. The difference is in the

1. Nelly Richard, 'Latinoamerica y la postmodernidad: la crisis de los originales y la revancha de la copia', in *La estratificación de los márgenes* (Santiago de Chile, Francisco Zeger Editions, 1989), p. 55.
2. Ibid.
3. Nelly Richard, 'Latinoamérica y la postmodernidad', *Revista de Crítica Cultural*, no. 3, 1991, p. 18.

shift from an operation of creative incorporation to one of direct international construction *from* a variety of subjects, experiences and cultures.

From Turkey to China, the work of many young artists, more than naming, depicting, analysing, expressing or constructing contexts, is done from their contexts in 'international terms'. Identities, like physical, cultural and social environments, are performed rather than merely shown, thus contradicting expectations of exoticism. The notion of *tigritude*, invented by Wole Soyinka in the 1960s to oppose that of *negritude*, is now more pertinent than ever: 'A tiger does not shout its tigritude: it pounces. A tiger in the jungle does not say: I am a tiger. Only on passing the tiger's hunting ground and finding the skeleton of a gazelle do we feel the place abound with tigritude.'[1] The metaphor emphasises identity by action towards the outside, not identity by representation or internal assertion, as it has often been the case in postcolonial art.

Today, more and more identities and contexts concur in the artistic 'international language' and in the discussion of current 'global' themes. *From*, and not so much *in*, is a key word for contemporary cultural practice. All over the world, art is being produced more from particular contexts, cultures and experiences than 'inside' them, more *from here* than *here*.

Art from Latin America has strongly contributed to this dynamic. Its identity neurosis is now less serious, something that facilitates a more focused approach to art-making. Contrary to Latin American art clichés, contemporary artists tend less to represent historical, cultural and vernacular elements, in favour of letting their backgrounds work from within their poetics. It is not that they have lost interest in what happens outside art. On the contrary: art from Latin America continues to be engaged with its surroundings; but context tends to appear less as raw material and more as an internalised agent that constructs the text. Difference is thus increasingly constructed through plural, specific ways of creating the artistic texts within a set of 'international' codes than by representing cultural or historical elements that are characteristic of particular contexts.

By this operation artists are slowly and silently democratising the dominant canons and power relations established in the international networks and markets. This new situation carries new problems, but points towards a

1. Wole Soyinka, *Myth, Literature, and the African World* (Cambridge, Cambridge University Press, 1976).

very plausible direction for culture in a globalised postcolonial world. It propitiates a polysemic and actively plural international environment.

The impact of contemporary migrations, with their cultural displacements and heterogenisation, and the rising of a more dynamic and relational notion of identity, have been thoroughly discussed, especially by diasporic artists and scholars. The impact on the (richer) country of reception and its culture by the immigrant and its action on a global scale within a postnational projection, which includes the expansion of transnational communities, all have been fairly emphasised. However, equal if not more important cultural and social mutations will come from massive urbanisation developing full speed in Africa, Asia and Latin America. On the other hand, we must remember that the majority of humankind does not migrate.

Another silent cultural revolution that is taking place is urban demographic growth in the so-called Third World. Consider that at the beginning of the twentieth century only 10 per cent of the planet's population lived in cities. Now, 100 years later, half of the globe inhabits urban environments. If urbanisation was characteristic of the developed world, and rural life predominated in the Third World, by 2025 urban population will prevail in the whole planet: five billion individuals, two-thirds of the world's inhabitants. But the crucial aspect is that two-thirds of them will be living in poor countries. Since 1975 the world's city-dwellers doubled, and they will double again between 2004 and 2015. This urban revolution is chiefly taking place in the non-Western world. To give an example, Bombay's population has quadrupled in thirty years. Obviously, cities are not prepared to afford such demographic shock, but, as Carlos Monsiváis put it, 'the city is built upon its systematic destruction'.[1] Urbanism and architecture, as we have traditionally understood them, are over.

Right now there are only two megalopolises[2] in the United States and two others in Europe. There are nineteen in the rest of the world, and their number will increase, mainly in Asia. Of the thirty-six megalopolises predicted in 2015, thirty will be located in underdeveloped countries, including twenty in Asia. New York and Tokyo will be the only rich places to appear in the list

1. Carlos Monsiváis, 'La arquitectura y la ciudad', *Talingo*, no. 330 (Panama City, La Prensa, 1999), p. 15.
2. Cities with more than eight million inhabitants.

of the ten largest cities. The cultural implications of this demographic trend are obvious. An important one is the complex, metamorphic and multilateral process that entails the substitution of the traditional rural environment by the urban situation, a clash that involves a massive number of very diverse people.

Living in a city does not mean living in a house: 100 million people do not have permanent lodging. The majority of them are children. The homeless are perhaps the ultimate city-dwellers: their home is the city itself. 'A home is not a house', Rayner Banham's famous phrase, is acquiring a new meaning today. But a city might not be a home either. Fear of the city, instead of the fear of wilderness, is a syndrome of our times. Before, jungles were the space of danger and adventure, whereas cities were the protected realms of civilisation. The situation has reversed nowadays: jungles are ecologically pure, rather idyllic areas that we enjoy on Discovery Channel, while big cities have become increasingly polluted, insecure domains of paranoia, where 'civil life' is more and more difficult.

Just by going through statistics one receives strong symbolic impacts. Sub-Saharan Africa has been stereotyped as the territory, par excellence, of wildlife and 'primitivism'. Today, on the contrary, it impersonates the deliriums of modernity and globalisation's short circuits. This region, associated with small villages and tribal life, has achieved the highest rate of growing urbanisation worldwide. In less than twenty years, 63 per cent of its inhabitants will be city-dwellers. During the next decade, fifty million people will move from the countryside to West African cities. In 2015 Lagos, with 24.6 million inhabitants, will be the third largest city in the globe, surpassed only by Tokyo and Bombay.[1] The myth of 'Black' Africa is gone with the twentieth century. Africa is no longer the jungle and the lions, but the new chaotic cities and their new (and wilder) urban lions. The colonial narrative of 'the heart of darkness' has moved to dwell inside modernity.

What implications will all these processes have for art and culture? Art is a very precious means of dealing with cultural disjunctions and finding orientations. Many artists from diverse places are reacting to and participating in these transits. There is also a plausible tension caused by displacements in the dominant artistic canons, their transformation by different cultural values,

1. All statistics are taken from *Mutations* (Bordeaux, Actar, 2001) and 'Ciudades del Sur: la llamada de la urbe', *El Correo de la UNESCO* (Paris, UNESCO, 1999).

the introduction of heterodox approaches and the ensuing predicaments for artistic evaluation.

Many issues are at stake: conflicts, social and cultural articulations; dialogues and clashes between neologic urban cultures and rural traditions; chaotic, wavering and dissimilar modernisations; massive diasporas, outrageous poverty, social contrasts, violence, terrorism, wars; shanty towns and their culture; global communications and huge zones of silence;[1] homogenising global tendencies and affirmation of differences; mutating identities, hybridisation, international networks and local isolation; and cultural shocks and assimilation. What about the implications for the individuals? After September 11, these problems have come to the forefront for all of us – and not only for the majority of humankind.

1. Gerardo Mosquera, 'Alien-own/own-alien. Notes on globalisation and cultural difference', *Complex Entanglements. Art, Globalisation and Cultural Difference*, ed. Nikos Papastergiadis (London, Rivers Oram Press, 2003), p. 21.

Prospectives for a New Classicality

Boris Brollo

Form should no longer adapt to Function,
but to Emotion.
Kevin Roberts, *Saatchi & Saatchi*

There was a time when the 'new' was sought after in that empty space between 'high' and 'low' culture where elements of '*genius loci*' were present, staying within the boundaries of visual arts as Achille Bonito Oliva taught us. Today this is no longer the case, as the entirety of visual culture has become stratified and spectacular. Being spectacular is contemporary art's heroic suicidal act.

I personally feel, however, that this is nothing more than the stirrings of rebellion which do not solve the fundamental question of broader skills of perception, which should involve exhibition visitors, as well as artists, critics and exhibit organisers.

It was in the 1990s that a new avenue opened, leading to a new way of looking at and understanding art – emotionality. During those years, artists were the protagonists of a silent revolution, which ended in the tragedy of 9/11. Every age, of course, has had its own conception of the 'golden age', some abstract and universal idea that can be labelled 'classicality'. The Greek canon, the golden section, the rediscovery of Greek humanism during the Renaissance, the three-quarter posture in the portraits of the 1800s, the impressionists' *en plein air* pose, Francis Bacon and his fixity, or, by contrast, the carnality of Lucien Freud, and, to conclude, American abstract expressionism. All of this has created an idea of painting as something eternal, just as it has made it classical in its inner structural dogmas.

To bring things a bit closer, let us consider Jean Clair's show *Identity and Alterity: Figures of the Body, 1895–1995*, held at the 1995 biennial in Venice, where we discover a convenient convergence between the cells by Louise Bourgeois and the medical studies and photographs on hysteria from the late nineteenth century. Also, we find that, in those years, a multitude of artists – such as Andres Serrano, the Chapman brothers Jake and Dinos, Damien Hirst and Cindy Sherman – were working on the theme of death and its visual conceptualisation.

In October 2004, the Pope, the highest authority of the Catholic Church, said that the thought of death is not to be detached from life: this was after 9/11, but that is another story, as we shall see later. Now, as death slowly draws closer, depicted in various artistic forms, the question is raised of waiting for death, which Baudrillard, in his libel 'The Spirit of Terrorism', explains as the waiting for an event, something that is already inside us. We all felt a subconscious angst, waiting for a tragic moment, like the Calvary of Jesus, that would strike a chord within our imagination. It is no wonder that the film *The Passion of the Christ* by Mel Gibson lingers on the sensationalism of blood and flayed flesh. We can say that in this film our angst of *being attacked* has found subsequent justification.

We saw, however, evidence that a great silent revolution of the arts had taken place much earlier. We had the fluxus movement that tried to spread the roots of art and make it common ground for everyone. '*L'arte è facile*' (art is easy) is what Giuseppe Chiari, a prominent Italian artist in fluxus, wrote, or '*l'art est inutile*' (art is useless), as French artist Ben Vautier believed. All this, however, raised, the problem of quality in the art world, and so we went back to '*arte povera*', launched by Germano Celant in a 1968 show, where art was found poor in means and materials, but revolutionary in the ideas of freedom and revolution. Mario Merz's *Igloos* were a reference to the legendary Vietnamese strategist General Giap; later, in the 1980s, Achille Bonito Oliva's trans-avant-garde movement recognised in Nietzsche's philosophical strategy of the eternal return the cyclical nature of painting, though these cycles were only palliatives. Although having merely climbed from the roots to the branches of the great tree of art, after the shock caused by the September 11 attack on the Twin Towers, we rediscovered art's true method: its tremendous spectacular quality, so deeply rooted in society, to become the tragic epos upsetting the world. Today we undoubtedly watch

China's exoticism with pleasure, as we did with the African contamination [infiltration?] of the show *Magiciens de la Terre*, held in Paris in the 1980s. We also witnessed Achille Bonito Oliva's meldings and boundaries drift at the 1993 biennial, and we can see, looking back, that they were all preliminary acts to the great tragic event. I remember that, in those years, we would visit art shows looking for works with 'energy'. The first to theorise about a 'show experience' was the quick-on-the-uptake Harald Szeemann, who would look for its *Zeitgeist*. Nonetheless, what we had seen in the 1960s with Viennese acting and fluxus was no longer there. Art meant as a cathartic and redeeming factor had contributed to opening the world's social doors and breaking sexual barriers.

To be sure, AIDS stormed upon the social scene of the 1980s, likened to a divine punishment, while, stemming from this aura of death, what was being prepared just around the corner was represented by some perceptive artists, such as Mike Kelley, Matthew Barney and others mentioned earlier. All this meant questioning society through the taboo of death, its fear and its terror, and it also concerned terrorism, the real revolution of these recent years. This has led us to reconsider our Western lifestyle, just as it has caused us to bring back into discussion all the values on which our civilisations are founded and how they can come together.

A deluge of images associated with what is social departs from this. Is it only a trend? Authors such as John Bock, Thomas Hirschorn and Jonathan Meese have been representing reality in different ways for years, and they have reconstructed a truer reality, closer to our inner and private selves.

In recent years, terrorist acts have accustomed us to be cautious, to be wary of appearances, to raise the critical threshold of our consciousness and to become more watchful. Has not this been the real purpose of art during the last decades? Was this not the critical stimulus we had been looking for in society? Was not *épater le bourgeois* (to amaze the bourgeois) the ultimate aim of any avant-garde? Moreover, which army would the terrorists be fighting against? A multi-armed army, equipped with smart bombs, intelligence supremacy, uranium-enriched bullets and a huge deployment of troops and forces supported by one of the most powerful military machines in the world? To all this, one can only 'fight' one's own personal 'delirium', as Baudrillard said: is it dream or reason? Is it the right of the strongest? How else to fight the strongest, if not through the art of war? The entire history of humanity is

the story of war being waged, so what is there to be so shocked about?

A while ago the issue was the democracy of art and its means of production. Today we are trying to understand which of these is the right move in a 'critical contextualism' that will have to operate more on art's usefulness than on its expressive methods. So deep is art's commoditisation that we do not dare think of getting rid of it; nonetheless it is still possible to challenge its clichés and disconcert its experts.

Today images of perturbing situations or installations that trigger physical discomfort or psychological uneasiness enjoy great success and attention. This is a positive sign, although disentangling oneself from so much pseudo-sociological rubble in order to search for true art is distracting and wearisome; this is where the art critic must rely on his or her cultural effectiveness. I believe that one cannot be a critic without being also an apostle of a new critical faith of a new artistic religion. No more playing around. Beyond good and evil – as Nietzsche said – all this has developed a new sensitivity and a new emotionalism that is artistic and social.

Emotionalism – that is the magic word! We had lost sight of it after the great Dalí's misleading and his critical-paranoiac system. He wrapped emotionalism in psychoanalysis, and in those years it was not understood because it was embedded in a totalitarian conception of art – art as a mission. Today we no longer have such a mission to carry out, as Milan Kundera notes. For this reason, art today travels along the lines of 'artistic discontinuity', in so doing mimicking music, cinema or even television commercials. Today a director may work indifferently on a drama, a comedy or a fantasy. Directors such as Spike Lee or Wim Wenders direct TV commercials that are based on visual emotionalism. Photography was born within this perspective too, as is easy to see, recalling Cartier-Bresson's idea of 'the decisive moment'. Therefore, today's artists can only live the *hic et nunc* (here and now) of instantaneousness. This is all there is to today's artistic philosophy. What is there to be sold? It is not the art work as such, but the emotion evoked by the work itself, its *carpe diem* quality, be it in a photograph, a video or an installation. It is precisely this 'aesthetic emotion' which is the new 'classical' root of contemporary art, or current art, as some prefer it to be called.

Furthermore, all this allows for an evasion of critical and aesthetic judgement. It allows us to be judges ourselves of the work and its content. This is a giant step, an important transformation that eliminates obsolete

heavyweights – the critic, the historian and the aesthete. Thus the bonds of mercantilism and historical art collecting are removed from the advantage of the connoisseurs' shared mindset, since they are no longer the happy few. Rather, they are open to society and operate for the overcoming of art as an induced need. In so doing, the foundations of critical judgement are laid, and this judgement literally starts with a gut feeling before it reaches the rationality of the mind; in time, it will become more refined through the mind's role.

We will look at a painting without feeling a need to possess it, and this goes for all beautiful things. This will produce an optimistic outlook on life and consequently on things that surround it. Little things will be as influential as big ones, as long as they satisfy us and make us feel good. Painting and the whole of art will work like music, mathematics and other realms, which means anything and everything associated with the psychic emotionalism of the individual, as there is no longer a 'subject' to be studied. Emotionalism eliminates the feeling of possession that is mainly associated with the psychological structure of sentiment. Emotionalism is the real content of 'current art', which neglects the artistic factor and its 'aesthetic character' and embraces a psychological quality. Emotionalism is that pierced spoon through which Saint Augustine's angel tried to empty the sea to fill his hole.

Translated from the Italian by
Christine Anne di Staola and Rossella Pacilio

Notes on Globalisation, National Identities, and the Production of Signs

Nicolas Bourriaud

The growing globalisation of the art world in general – and the increase in biennial shows of contemporary art in particular – reflects a veritable revolution in contemporary culture, one in which the distinction between the so-called 'mainstream' and the alleged 'margins' no longer holds. There is no more mainstream, but rather a multitude of streams that mutually feed into, diverge from, and flow in relation to one another. Bangkok, where a major exhibition in July 2004 featured the key figures of the Thai new wave, was a no less intense place than New York at the same moment. The recent biennial in Moscow, the explosion of Chinese creativity and the slow structuring of an artistic circuit in Black Africa are symptoms of a cultural globalisation that extends far beyond mere economic globalisation. Nowadays, no truly self-contained cultures exist; there do exist, on the other hand, unequal levels of economic development and a worldwide struggle between 'contemporary' culture and traditional cultures. What differentiates nations in 2005 is above all specific economic systems in different stages of the evolution toward global capitalism; there are also highly diverse reactions to the standardisation stemming from a modernisation that has little to do with artistic modernism, being primarily economic. To begin with, not all countries have emerged from industrialism, whereas most Western societies have already reached a subsequent stage of development. The West has become an information society; that is to say, it features an economy in which the supreme value, as the sociologist Manuel Castells has pointed out, is information created, stored, accessed, processed

and transmitted in digital form. In such a society, Castells goes on to argue, what has changed are not the activities performed by humanity, but rather its technological capacity to generate direct productive power from the very thing that makes our species unique: our higher aptitude to handle symbols.[1]

If we accept the idea that the Western economy is postindustrial, centred on the service sector, on the reprocessing of raw materials from the former 'margins', and on the management of interhuman activities and information, then we can see that artistic practices will necessarily be transformed.

But what of artists who live in industrial, or even preindustrial, societies? Can we really believe that all artistic imaginations are created free and equal today?

Indeed, rare are the artists originating from 'marginal' countries who have succeeded in joining the mainstream of contemporary art while remaining in their country of origin. A few have nevertheless managed to free themselves from cultural determinism by uprooting themselves and replanting their native culture in soil that is not their own.

Artists such as Rirkrit Tiravanija from Thailand, Sooja Kim from Korea and Pascale Marthine Tayou from Cameroon – plus dozens of others who might be mentioned here – work on the signs of their native culture from within the economically 'mainstream' countries in which they live, as though the import and export of forms truly function only right in the middle of the global circuit. But this could be a trap.

For what is a global economy? It is an economy able to function on a planetary level, in real time. So is there really a global culture able to 'function' on a planetary level? This is the issue to be addressed in coming years.

Ever since the fall of the Berlin Wall in 1989, the unification of the global economy has led to a spectacular standardisation of cultures, rather than the emergence of a worldwide culture. In the 1990s there appeared what is called *multiculturalism*. According to certain critics, contemporary art is progressively falling into line with the movement toward globalisation; but the standardisation of economic and financial structures does not lead to a diversity of forms, which is the accurate, if inverse, reflection of this growing uniformity.

1. Manuel Castells, *L'Ère de l'Information, vol. I: La société en réseaux* ('The Rise of the Network Society') (Paris, Fayard, 1998).

This is the standpoint from which we can appreciate the significance of performance art and happenings in countries that were formerly part of the Soviet bloc: they apprise us of the local impossibility of getting art objects into circulation, of the political virtues of cathartic action and of the importance of *leaving no traces* in a hostile ideological context. Which just goes to show that contemporary art is above all contemporary with the economy that envelops it.

We would furthermore have to be truly naïve to believe that a contemporary artwork is a natural expression of the culture from which the artist has sprung, as though culture constituted an independent, closed universe. Correspondingly, we would have to be truly cynical to promote the idea of the artist as a 'noble savage' in his or her native idiom, bearer of an authentic difference not yet contaminated by White colonialism – that is to say, by modernism.

(Far from constituting a simple mirror in which a given period might recognise itself, art does not derive from the imitation of contemporary procedures and fashions, but rather from a complex interplay of resonances and resistance that sometimes pull art closer to concrete reality and sometimes propel it toward abstract or archaic forms. While the use of machines, or advertising imagery or binary language hardly suffices to make an artwork 'contemporary', we have to recognise that the acting of painting no longer has the same meaning today as it did in the days when it meshed with the world of work like a gear in a clockwork mechanism. That this is no longer the case in no way prevents painting from continuing to exist, but any attempt to deny the transformation renders painting invalid. Art conveys the overall evolution of productive processes, the contradictions between practices and the tensions between a given period's image of itself and the image it truly projects. So at a time when representations intervene between people and their everyday lives, or between people themselves, nothing could be more normal than an art that sometimes eschews representation to become part of reality itself.)

The logical fate of 'human history' – understood as the interaction and growing interdependence of the groups and individuals making up humanity – is to become universal. Global art and multiculturalism thus reflect a new stage in the historical process triggered by the fall of the Berlin Wall, without however always coming up with a pertinent, satisfactory answer.

The art world is now dominated by a kind of diffuse ideology, multiculturalism, which claims in a way to resolve the problem of the end of modernism from a straightforward, quantitative standpoint. Because more and more cultural specificities are enjoying visibility and consideration, this must mean that we are on the right track. And because a new version of internationalism is allegedly taking over from modernist universalism, the achievements of modernism will be preserved.

Charles Taylor, the Canadian who has developed a theory of the *politics of recognition*, argues that it is vitally important to grant dignity to cultural minorities within a national community. What holds for North America, however, does not necessarily hold elsewhere. Can we be sure that Chinese and Indian cultures are 'minorities' ready to be content with polite recognition? How can we reconcile the validation of 'marginal' cultures with the codes (or values) of contemporary art? Does the fact that contemporary art is effectively a Western historical construction, a fact that no one would dream of challenging, really mean that tradition needs to be rehabilitated?

Artistic multiculturalism settles this issue by refusing to decide. It thus comes across as an ideology of the domination of the West's universal language over cultures that are valued only insofar as they turn out to be atypical and therefore embody a difference that can be assimilated by that international language. Within this alleged multiculturalism, any good non-Western artist must bear witness to his or her cultural identity as though worn like an indelible tattoo. The artist is therefore immediately presented as contextually alienated, creating a spontaneous opposition between artists from 'marginal countries' (assuming they display their difference) and 'mainstream' artists (who must adopt a critical distance vis-à-vis the principles and formats of the globalised culture). This phenomenon has a name: reification. In multiculturalist ideology, an Algerian or a Vietnamese artist has an implicit duty to produce imagery based on his or her alleged difference and on the history of his or her country – and, if possible, also based on Western codes and standards (such as video technology, which now constitutes a perfect 'green card' for entry into the Western market, being a kind of technological leveller and a de-territorialising medium par excellence).

Multiculturalism thus adopts an ideology of the naturalisation of the culture of 'the Other'. It also presents the Other as a putative nature reserve,

a reservoir of exotic differences distinct from American culture, perceived as globalised, hence synonymous with universal. Artists, however, reflect not so much their culture as the mode of production of the economic (and therefore political) spheres within which they operate. The emergence of contemporary art in South Korea, China, northern Africa and the Republic of South Africa reflects a given country's level of cooperation with the process of economic globalisation; its national entrance onto the international art scene can be directly deduced from the political upheavals that have occurred there. But what image does a country acquire? It has to be conveyed in simple terms, or else difficulties will certainly arise. In her video work, the Iranian artist Shirin Neshat was able to provide a straightforward and direct visual translation of her culture and the distance she has taken from it, and her international success probably comes from her ability to supply Iran with an image that differs from the simplistic ones currently circulating in the global imagination.

There nevertheless exists an alternative to this globalised vision of contemporary art – an alternative that asserts there are no pure cultural biotopes, but rather traditions and cultural specificities riddled by the phenomenon of economic globalisation. To paraphrase Nietzsche, there are no cultural facts, only the endless interpretation of those facts. What might be called *interculturalism* is therefore based on a twin dialogue: one between the artist and tradition, and another between that tradition and the set of aesthetic values inherited from modern art, which currently form the basis of international artistic debate. Major intercultural artists today range from Rirkrit Tiravanija and Navin Rawanchaikul to Pascale Marthine Tayou and Subodh Gupta via Heri Dono and Sooja Kim – they creatively erect their own idiom on the modernist ground plan, reinterpreting the history of the avant-gardes in the light of their own specific visual and intellectual environment, thus building on their tradition to reach the greatest number of people. The quality of an artist's work depends on the wealth of his or her relationships with the world, and these relationships are determined by the economic structure that more or less powerfully formats them – even if, fortunately, each artist theoretically possesses the means to escape or elude that formatting. 'The important thing', said Jean-Paul Sartre, 'is not what people have made of you, but what you yourself make of what people have made of you.'

The global creative imagination is a *postproductive* imagination – by which I am referring to all artists who create works from already produced objects, whether they be other artworks, films, industrial products and so on. Everything is already there; the artist merely weaves signs between them. Being subjected to an incessant flood of objects from the culture industry is another phenomenon of our times – artists from Dakar to Tokyo are working in a dense jungle of quotations and forms that now shape our everyday lives, yet did not exist just fifty years ago.

The art of the twentieth century grew from the industrial revolution, even if the effect of that revolution was long in making itself felt. When in 1914 Marcel Duchamp exhibited an ordinary bottle rack as a piece of sculpture, the production tool he used was a mass-produced object. He was thereby carrying into the sphere of art the capitalist mode of production (working on already accumulated labour) even as he aligned the role of the artist on the world of exchange. According to Duchamp, an artist is suddenly a merchant who merely shifts products from one place to another. Duchamp began from the principle that consumption is also a mode of production, as did Marx, who wrote in his *Introduction to a Contribution to the Critique of Political Economy*: 'Consumption is simultaneously also production, just as in nature the production of a plant involves the consumption of elemental forces and chemical materials.' A product only becomes truly a product once it is consumed, because 'a dress becomes really a dress only by being worn, a house which is uninhabited is indeed not really a house'. Such was the first virtue of these consumer items that Duchamp transformed into artworks and dubbed 'ready-mades': they established an equivalence between selecting and making, between consuming and producing.

This postproduction art has therefore emerged in the very particular historical context of our age. Indeed, at the dawn of the twenty-first century, human beings live surrounded by transmitters – television, radio, newspapers, advertising and publicity of all kinds. What now characterises our daily existence – to varying degrees, depending on whether you live in New York or Djibouti – is the fact of being in the constant midst of an infinite stream of broadcasts (indeed, of discourses) that we then transmit ourselves. We have ourselves become media. We pass on messages that come from elsewhere without really thinking about it. What characterises artists today is precisely the fact that they are aware of this fact – and that they act

to interrupt, deform or disturb all these signals by creating artworks that give us pause. An artwork is a pause in this infinite process, a halt in the incessant stream of social broadcasts. It should be said of such broadcasts that they can adopt the most diverse of material forms, yet all of them shape our behaviour, guide our thinking and influence our way of seeing the world – regardless of whether we are American or European, African or Arab. They coagulate most of the time in real scenarios (the ideal story of the 'American family', the code of conduct of a Muslim or a Catholic).

In his essay titled 'Arts de faire: l'invention au quotidien' ('The Practice of Everyday Life'), the philosopher Michel de Certeau analysed the developments that underpin the notions of production and consumption. Consumers, contrary to popular belief, are in no way passive; on the contrary, they perform a set of operations that might be called *silent production*, one that is almost clandestine. That is because using an object necessarily means interpreting it, and exploiting a product can perhaps mean betraying its original concept in one way or another.

Beholding, viewing or analysing an artwork means knowing how to subvert it; use is a kind of micro-piracy that constitutes what might be called an act of postproduction. Starting with an imposed language (the *system* of production), each speaker constructs his or her own sentences (the *acts* of everyday life), thereby reappropriating, through a micro-tinkering process, the last word in the productive chain. What counts is what we do – whether artist or not – with the components we are allocated.

Thus we are all 'occupants of culture' – every society constitutes a text or a framework that allegedly passive users subvert from *inside,* via postproductive practices. Every work, suggests de Certeau, 'can be occupied like a rented apartment'. By listening to music or reading a book, we generate new material – we produce. And every day we are allocated new methods for organising this production: remote controls, recording equipment, computers, MP3 devices and tools for selecting, editing, recomposing. Postproduction artists are agents of this evolution, skilled workers in the task of cultural reappropriation. Art now constitutes a tool that allows us to view different versions of our own world.

As Jean-Luc Godard used to say, 'Culture is the rule – art's the exception.' It follows that this exception – art – refers to the entire set of activities through which worldwide culture is shaped and transformed. It

also follows that artistic activity does not involve obeying a tradition or belonging to a cultural community, but rather learning to detach oneself, at will, to reveal something that has never been displayed.

Translated from the French by Deke Dusinberre

The States of the Strait

Nadia Tazi

The English call the Strait of Gibraltar *the gut,* the intestinal passage, possibly a reference to both its narrowness (seventeen kilometres at the widest point) but more importantly the extent of the attachment they feel for it. For the Arabs, it was long known as *the Andalusian canal*: not a boundary but simply a passage within the same land. Its profuse imagery then suddenly flips, not without resentment, yielding gods and giants, the dust of empire, the crusades, commerce and all kinds of traffic, drowned dreams, battles and mythic designs. But today, its etymology says it all: from the Latin *destringere,* which is also the root of *distress* and which means 'bound on one side and the other', 'keep apart', 'hold back', 'prevent', 'stop'; *strictus,* meaning 'narrow', and *distrinctus,* 'chained', 'shared', 'hesitant'. *El Destrecho, the Strait, al-madiq,* is no longer a boundary, in fact. It designates the most violent demarcation line: the edges of a barbed wire barrier of meanings that trace the line separating two worlds that we call indifferently North and South, Orient and Occident, Islam and Christianity, Europe and Africa, but which express more than any one thing: 'Everything is hiatus'.[1] Nothing seems more in agreement in this space where history and geography meet on a single line that we might call *destinal.* The political, the symbolic, all levels of life, information, demographics, even mythology partakes of this general economy through the figure of Hercules who separates the continents. Its character, at once total, hyperbolic and disjunctive, creates the unity of the place: nowhere is the evidence of separation so complete and so brutal.

1. Zakya Daoud, *Gibraltar croisée des mondes* and *Gibraltar improbable frontière* (Paris, Séguier, 2002).

The Strait can be called 'totalitarian' in that it has become, by virtue of its murderous lock-out and abysmal inequalities, the place where an entire continent runs aground. All of Africa rises up towards these shores, while rich, old Europe barricades herself behind her fears: *mundus distrinctus*. What preoccupies the present era is not the shock of civilisations but the distress of the Strait: that is, in a finite world saturated as far as one can see, not only the contiguous antagonisms or the dissonances that tear at its globalised continuity, but the process of exclusion and rejection made manifest by these border zones.

Tangiers is therefore the visible point of an undefined and potentially vast complex. In this sense it is never anything but a synecdoche. But situated at the outposts of the Strait, it becomes the focal point of the buried continent, thus condensing a very particular condition and temporality. 'It's a city suspended between earth and heaven, a window, a perch, a place of fascination and of betrayal, an outlaw space.'[1] The city of Paul Bowles and the beat generation has kept its image as cosmopolitan and as intruder. But it is also becoming known for its slums – cradles of terrorism – and for its groups of illegal immigrants, thousands of whom have perished at sea.

Two tragic ways to flee and to waste one's life: one in the culture of death, and ultimately, for a handful of them, in a suicide attack (Madrid, 11 March 2004); the others in exile to the Other Shore, in the claws of gangs of middlemen and recruiters. Being without rights and outside the law, underground people, extreme in their resolute confrontation with death, they testify to disaster. They demonstrate, each in his or her own way, a generalised failure in which the disdain of leaders, poverty and the indigence of the Islamic states conspire to claim their deadly share of naked life, life for death, in the country's demographic surfeit. This insurmountable precariousness instils in each generation the feeling of being in excess, of being completely worthless, unable to find a place in the sun, struck down by impossibility, sacrificed to the fatality of the Strait: in other words, a destiny of devastation, one that involves a certain way of relating to oneself. These people in flight are traversed by dischronicity; they bring together disparate historical realities. But they are so in a manner that is rigorously antithetical: symmetrically. The first ones, the radical Islamists, choose to cross the Strait in order to bear witness and to die in the name of God. They rely upon a

1. Paul Bowles, quoted by Zakya Daoud in *Gibraltar improbable frontière*, p. 172.

fascist ideology which, speculating on despair, calls for a return to the Origin and hatred of the West. Theirs is a moralistic purity obsessed with identity, with a revolt against Authority, along with a refusal of the Other that corrupts and divides consciences and that wants to reverse the course of time. We know their reactionary slogans and the pitiful passions they incite: 'The difference between you and us', says one of their chiefs, 'is that we love death and you love life.' The others – the immigrants – try their luck by risking their existence in the name of survival and for a mad desire for Europe, land of liberty and the possible; the glittering lights of the forbidden city may be seen at a short distance from Tangiers; they dimly burn, virtually, in every household, on the television screen. These are the *harragas* – the 'burners', in the north African Arabic dialect – who destroy their papers by embarking on the *pateras*, in the hope of finding a life, a real life other than in a country that refuses them either dignity or a future.

The democratic state, for its part, knows only the most obscure part of sovereignty: it has the power to 'put to death' or to free the illegals from the social nothingness in which they have been submerged. The messianic states of the Strait: to depart is to tear oneself away from the world and from life in the hope of Judgment and Resurrection. To grant them resident cards is to accord oneself the divine right of rebirth;[1] to refuse to do so is to condemn them to a phantom life between death and redemption.

But if on one side Authority relies on the most archaic principles of power and hides itself behind a politics of security, and if European public opinion becomes more racist each day and affirms itself through the rejection of the Other, what should one think of the systems on the other side that provoke similar reactions on the part of their youth? What are the conditions for behaviour that oscillates between the will to survive and certain death? It was Hassan II who explained, with the feigned cynicism of which he was capable: 'They act from the pressure of need. Any reasonable man in a similar situation would do the same.'[2]

One might counter by saying that here as there it is only minorities who risk the adventure all the way. But if it is true that not all Islamists are terrorists, neither does one know if, in such groups, the engagement against

1. Smain Laacher, *Après Sangate, Nouvelles Immigrations. Nouveaux enjeux* (Paris, La Dispute, 2002).
2. Daoud, *Gibraltar improbable frontière*, p. 227.

the Other is always accompanied by a firm condemnation of fascism and extreme violence. Too often, things remain ambiguous. By the same token, if not all the young candidates setting out actually move to action, we do know that the majority aspires to do so.[1] The Strait drains energies and thoughts; it obsesses and consumes people of all ages and conditions and ends by defining a way of life, a social pathology that affects the entire city; disoriented, as if in mourning, at one remove from itself in the futility of the suspension between two worlds. It is generally described as a narcotic, hardly a neutral expression in a region that lives on the drug trade and whose popular culture often engages in rites of possession. The anthropologist Stefania Pandolfo speaks in this connection of *barzakh*, a term taken from Islamic mysticism which designates 'all that masks, all that blocks the light'.[2] In other words, matter, that substance of night and death which, to maintain in a state of non-being is dreaded by the soul as abjection itself, gives rise to a radical dualism and to exile, its result. Between narcosis and the naked desire to flee, the future *harragas* live suspended in an elsewhere that is nowhere, in an ecstatic temporality, eternally fixed on the sea's horizon. Even before they lose themselves in the limbo of an underground existence on foreign soil, they have already lost themselves, rejected themselves. The spectral states of the Strait: stupefaction that reveals a degraded history, a mode of being in a dispossessed world that empties itself of all substance; the power of televised simulacra and their seduction, the melancholy points of land and the frontiers with their games of fraud; exile, and the vicissitudes of geopolitics, and the incurable nostalgia for a future that will never have existed. Tangier has become an *invisible city* like the cities of Calvino. And the Moroccan specificity – its Western, dual vocation, traditionally vaunted as a privilege – has turned back against the country since the moment a majority of the population experienced exclusion both within and without, and the hinterland of Africa presses in at the borders.

These ambiguous modes of being are what Yto Barrada, a young Moroccan artist, succeeds in realising in her photographs (which preceded the attacks in Madrid). In the photos, the Strait dominates despotically, that

1. According to a 2003 poll, more than 70 per cent of Moroccans would be willing to leave their country. We also remember how Chirac was greeted with shouts of 'visas' during his 2004 visit to Algeria.
2. Henri Corbin, *En Islam iranien* (Paris, Gallimard, 1971), vol. 2, p. 109, quoted in C. Jambet, *Le caché et l'Apparent* (Paris, L'Herne, 2003), p. 78.

is, by virtue of their absence. Off-stage, they never appear except in the circle of dependence they project, rendered palpable in these images. The photos of the 'people of the Strait' translate deafly and without compromise the climate of disaffection and absence that transforms this place in the negative. By their refusal of any pathos, the photos work towards the silent and cold reinstatement of this distracted poverty and the disintegration that erodes the city. They do so in such a way that, although they confine themselves to banalities, they reveal the indifference that belongs to waiting and to daily need, and a refusal of spectacle. This transparence reveals more than all denunciations. 'I have the feeling I see phantoms,' says Yto, 'things that the people don't see.' Closely designed but without ostentation, the rigour of the images could almost lead one to believe that one is actually entering the solitude of the states of the Strait. Their insidious lucidity illuminates nothing but testifies to the death-wish at work. No expressiveness then; rather a reserve which the pressure of the Strait penetrates only minimally, by a generalised sense of floating, and above all by detail, like a vague reminder that signals its presence. No local reference or high relief, but muted tints that accompany the insignificance of objects, immobile and anodyne postures. The generic landscapes of what recently was termed 'underdevelopment', which refer to a primal dereliction or to definitive sterility, are surrounded by vacant lots, unfinished constructions and the holes of savage urbanisation. The sadness of the provisional, left to disintegrate. No faces to decipher nor orientalist clichés: one can seek in vain the profile, the draped figures or the photogenic picaresque typical of Arab exoticism. There are only faces of anonymous children, mysterious in their impassiveness, bodies seen from the back, always from the back, random impersonal movements, scenes that at first disturb us little, suggesting only a kind of abstract weakness or dubious calm, inherent in the cardinal injunction of the *sabr*: the Qur'anic virtue of perseverance, and faintly, the experience of objectification which conditions and depicts an existence that is totally destitute. One glimpses a factory, torn painted paper, the imprint of a ball against a wall. Or again, a handful of children playing soccer while, behind the goal, in the foreground, one of them uncertainly slips through the wire fence that encloses the terrain. In another image, asphalt occupies the centre, an emptiness at the heart of things, and around the edges, on the diagonal, on one side, there is a group of women in *djellaba* crossing the street; on the other, the silhouette of a small child

carrying a model sailing boat (a caravelle?), almost as large as himself. And one of the most forceful photos shows two men in grey costume embracing each other's backs in a seedy decor, one of them massive in the foreground, the other, much smaller, visible only by his arm that encircles the back of his acolyte: virile homosexuality? Suffocating embraces in which each holds on to the other, or is it the weak greeting the strong?

It has been said (most frequently, in the photos of Yto Barrada) that it is precisely what escapes our view that really matters and that traces in the negative the edges of the drama, such as it plays itself out silently, before – or after – its entry into the margins. Because of that, it is necessary to have an informed reading capable of recognising the full political dimension of the work; in other words, to see the double eclipse that it achieves. To appreciate its irony one must apprehend the distance it posits from realism, as from any kind of ostentatious mastery, as an echo of the people of the Strait. Not without losing sight, in another sense, of the cosmetic imagery that normally vaunts it as 'the most beautiful country in the world'[1] to tourists and to foreign countries. Or, on the other side, the misleading accounts of immigrants who, returning home each year, ply the unfortunate creatures left behind with the myths of a European El Dorado. These images are the sort that situate themselves in between, representing the narrow, twilight space of the Strait in two ways: by refusing all the obvious lies that envelop this country and by testifying to a basic betrayal leading to absence, self-abandonment, distress; the illusion of a *gha'ib*,[2] an elsewhere that inhabits people and turns them away from themselves. But there is something else in these photos besides demystification. While retaining this subversive power, these photos are inscribed in another aesthetic moment than that of modernism. They require bifocals because they are perfectly consistent with a certain tendency of contemporary art that attempts to 'document' realities and ordinary practices in a manner that is both politically modest and formally understated. We can relate them to what Jacques Rancière calls '*l'art relationnel*',[3] a procedure seeking to establish social relations where none exist. But in a post-utopian context claiming the end of everything (art, politics and the two of them together: the radical politics of art), it appears in a very

1. Advertising slogan designed to sell Morocco to the tourists.
2. *Gha'ib*: literally meaning 'absent' (adjective) and 'absent person' and *ghaib* (the invisible) [Editor's note].
3. Jacques Rancière, *Malaise dans l'esthétique* (Paris, Galilée, 2004).

subtle manner, without promise or polemics, by displacing (to the extent of rendering them invisible) the very limits of art and of conventional imagery – whether commercial, mediatised or simply existential. In addition, the logic of the critical confrontation is muted by an ambiguous design: a design in which what is visible is the very gesture that identifies the singularity of the artistic presumption with respect to the prose of this degraded world. The strength of this work lies undoubtedly in that it is able to represent these two positions. What remains, clearly, are the ambiguous states of the Strait; a remarkable play of boundaries between the theme of the trouble endemic to this frontier or *glaucal* climate, and the political and aesthetic vocation of the photographs in their expression of divergent historical realities and meanings.

This coincidence inevitably raises the question of address. Evidently, these images are not received in the same way in Tangiers as in Witt de With, in Rotterdam, for example, where they have been displayed.[1] It is highly possible that what is immediately perceived by people of Tangiers – the photos' critical charge – loses its effectiveness elsewhere. Or rather, in changing the context and in expressing only a small detail of the political relation and of its displacements, they seem to empty themselves to the point of nearly slipping into nihilism. But in Morocco, on the other hand, it is the aesthetic dimension of this work that can be misunderstood: some people might be set off by the apparent triviality of the object and its form, since tendentially they expect this exhibit to deliver all the prestige of art *in the grand manner*: from the virtuosity of its savoir-faire and the smartness of the style, even unto the dignity of its themes, including the density of meaning associated with the mimesis which ought to govern the images. It is possible that in turn, these images are the site of a blind criss-crossing between the two shores of the Strait, as between the political and the aesthetic, each side opposing the other or merely staying put.

How could it be otherwise? Westerners have given up on art's emancipatory function and have attempted all kinds of dismantling projects to effect the deconstruction, derision, dismembering and the suspension

1. Yto Barrada, *A Life Full of Holes*, The Straits Project. Witte de With Center for Contemporary Art, 26 June–22 August 2004. In the same vein of this work, see *Fais un fils et jette-le à la mer...* ('Bring up a son and throw him into the sea...'), an experience of photography workshops led by Yto Barrada, Anaïs Masson and Maxence Rifflet with teenagers of the associations *Jeunes errants* (Marseilles) and *Darna* (Tangiers) (Editions Sujet/Objet, 2004).

and exhaustion of meanings: artists now play only with the undecideability between daily life and art. Why should one admit elsewhere that everything is *equally* representable and that all that is needed is to select a common object and exhibit it with critical commentary in order to elevate it to the realm of art? And it is not true, as is so often supposed, that Arabs, as Muslims, are iconoclasts, having but an adversarial familiarity with images in general, but that they depend on another '*partage du sensible*'.[1] To put it briefly, the principles governing the visible (and the invisible) are consistent with theologico-political laws. They emanate from an authoritarian regime which, attached to the One, instructed in the social hierarchies as in the interpretation of the sensible world, which must – among modernists at least – be subject to the laws of representation and organised according to a rationality that is often hypostasised; and which, aspiring to be universalist and techno-scientific, nonetheless stops at the very edge of the political realm. Even though we know almost nothing about the institutions and the attitudes that condition art in that part of the world, there is every reason to believe that art is neither always autonomous nor subject to the fragmentation of meaning, but is devoted to another function, to a meaning, either that of a celebration (religious or political) or that of the questioning of norms of power. Further, artistic pleasure might not consist merely in *suspending* the rules governing meaning but rather in intensifying them or eventually even in contesting them and testifying to its dissidents. And the boundaries that separate art from ordinary life remain decisively drawn: on the modern side they not only oppose it to popular culture or irreducibly to the world of the commodity as previously occurred in the West; they also cross dividing lines between globalised consumer culture that go beyond disjunctive identities and that of a high culture of recent immigrants, reserved for a tiny number, and most particularly for those of the diaspora.

Briefly then, the norms that define the relations between bodies, images, symbolic references and temporalities are not the same, neither from one Arab country to the next, nor between these countries and those of the West, and they do not even always coincide within Morocco itself, where it is evident that social differences exceed the play of artistic distinctions. One might reproach oneself for calling up such evidence if it were not so often left unmentioned, if the disparities of historicity were not ceaselessly

1. Jacques Rancière, *Le partage du sensible* (Paris, La Fabrique, 2000).

eroding these societies in a muted way, like tectonic plates whose heaves and shifts shake the ground of certainties, identifying many of the problems – notably Islamicism. One cannot explain the reception given the bearers of this ideology by the popular masses without considering how it relates to discordant temporalities: the Wahhabites, for example, intend to advance in the twenty-first century by importing technology and adhering to a programme of neoliberal capitalism at the same time as they perpetuate a notion of essentialised time that is frozen in the name of a most sacred identity; and while they advocate the contrary, the Islamists perpetuate a schism with respect to modernity in choosing their position, that of a regressive mythology and a refusal of the Other.

It is not, in this case, therefore, a matter of ignoring, in the name of artistic cosmopolitanism and the political openness that it is supposed to engender, a tension that incidentally permeates the works themselves. Nowadays, art can be considered political in a number of ways, according to several paradigms provided that one refrains from masking or compromising its problematical heteronomy, as it might be condensed by the notion of dischronicity. One should say first that the photos of Yto Barrada give back to the people of the Strait a presence they had lost. A presence unto a self that they no longer inhabit and from which Yto Barrada draws out the malaise: they can confront it through these images, which constitute a recognition that is usually refused them. By introducing these ordinary people into the space of high culture, the photographs signal consideration and respect. And it is important that this presence be accorded discreetly, without demonstrative emphasis, and by effacing a third spectator. So much the more because these photos also open up a space of overlapping questions, linked to the boundaries in the logic of time and space, about the relationship between politics and aesthetics, about social and cultural distances. These photos are not content merely to interrogate the states of the Strait: how to live outside oneself in this dejected temporality, between two exclusions? Disturbing, they are also disturbed, partially hidden, as if they, too, were unable to escape the effects of the Strait. We might say that they intervene as metalogues in Geoffrey Bateson's sense: they reproduce, by means of their effects, such disjunctive and ambiguous games, reflecting thus the complexity of the globalising world.

Translated from the French by Lucy Stone McNeece

Beginning with Edward Said

Joseph A. Massad

Edward Said, deeply steeped in the literary tradition, was a foremost analyst of the discourses of power and knowledge of modern Europe, especially as regards Europe's emergence as an idea articulated through its imperial expansion. His literariness and engagement with the discursive are what informed his analysis of how Palestine and the Palestinians emerged within European Orientalist thought and its Zionist correlate. But Said did not limit his investigations to the discursive: he was also informed by the visual register, whether in the imaginary dimension of thought and fantasy, visual representation in literature itself or actually existing visual representations and artistic productions of the worlds that Europe constructed, including Palestine. In this essay, I will explore the ways that Said *saw* Palestine and the role he accorded the visual in relation to the Palestinians.

How does the visual begin to read the Palestinian situation for Said? Can the visual provide a venue for looking at Palestine and Zionism from the standpoint of the Palestinians? It is in considering these questions that the centrality of the visual and its interpretation lies for Said when looking at the Palestinian Question. If, as Said saw it, Michel Foucault fascinated him because he began his historical and philosophical inquiries with the visible, the seeable, and then moved to the discursive, the sayable, Said had begun with the discursive and then moved to the visible. Said's book *After the Last Sky*[1] is an introduction to the dialectics of seeing and blindness, and to the role of the critic in appreciating and interpreting the visual. It is in a sense an explication of how the visual would begin to read Palestine and how Said

1. Edward W. Said, *After the Last Sky* (New York, Pantheon, 1986).

himself could begin again with the visual in relation to Palestine. But before
we look at Said's visual beginnings, it is important to look briefly at the way
Said began with the discursive.

Edward Said was born in Jerusalem. This biographical fact merely made
Palestine a point of origin for him. Indeed, Said had much aversion to the
idea of origins. For him, Palestine *became* a point of departure, or more
precisely a 'beginning' as opposed to an origin, a notion he associated with
the theological, and which therefore had little purchase in his decidedly
secular life. For Said:

> beginning is basically an activity which ultimately implies return and
> repetition rather than simple linear accomplishment, that beginning
> and beginning-again are historical while origins are divine, that
> a beginning not only creates but is its own method because it has
> intention. In short, beginning is making or producing difference ...
> which is the result of combining the already-familiar with the fertile
> novelty of human work in language ... Thus beginnings confirm,
> rather than discourage, a radical severity and verify evidence of at
> least some innovation – of having begun.[1]

Palestine was a beginning for Said because it involved his active intention.
For him 'between the word *beginning* and the word *origin* lies a constantly
changing system of meanings ... I use *beginning* as having the more active
meaning, and *origin* the more passive one: Thus "X is the origin of Y," while
"the beginning A *leads to* B."' For Said, 'ideas about origins, because of their
passivity, are put to uses' he believed 'ought to be avoided'.[2]

It is because of such uses that Said did not originate *in* Palestine but rather
began with it. This distinction is crucial because, as he tells us:

> beginning has influences upon what follows from it: in the
> paradoxical manner, then, according to which beginnings as events
> are not necessarily confined to the beginning, we realize that a major
> shift in perspective and knowledge has taken place. The state of mind
> that is concerned with origins is ... theological. By contrast, and this
> is the shift, beginnings are eminently secular, or gentile, continuing
> activities ...Whereas an origin *centrally* dominates what derives from

1. Edward W. Said, *Beginnings, Intention and Method* (New York, Columbia University Press, Morningside Edition, 1985), p. xvii. The book was first published in 1975.
2. Ibid., p. 6.

it, the beginning (especially the modern beginning), encourages non-linear development, a logic giving rise to the sort of multileveled coherence of dispersion we find ... in the text of modern writers ...[1]

How then did Said begin? How did Palestine begin for him? How did he begin in and decidedly with Palestine?

While Said articulated his ideas about musical counterpoint as the basis of reading texts and analysing historical events in a relatively late work, namely *Culture and Imperialism*, he had internalised this method much earlier in his scholarship, most eminently in his work on Palestine. For Said, to look at things contrapuntally is to

> be able to think through and interpret together experiences that are discrepant, each with its particular agenda and pace of development, its own internal formations, its internal coherence and system of external relationships, all of them coexisting and interacting with others.[2]

In *Orientalism*, Said had set out to do just that when he insisted that the history of European Jews and the history of anti-Semitism must be read in tandem with the history of the Muslim Orient and the history of Orientalism. If in an earlier work he had asserted that the 'Palestinian Arabs, who have suffered incalculable miseries for the sake of Western anti-Semitism, really do exist, have existed, and will continue to exist as part of Israel's extravagant cost,'[3] in *Orientalism*, he would gesture towards the process through which Palestinians became linked to that very history of European anti-Semitism, indeed how the history of anti-Semitism is intimately connected to the field of scholarship known as *Orientalism*.

It is there that Said *intended* to begin with Palestine. He begins that interrogation by affirming that 'what has not been sufficiently stressed in histories of modern anti-Semitism has been the legitimation of such atavistic designations by Orientalism, and ... the way this academic and intellectual legitimation has persisted right through the modern age in discussions of

1. Ibid., pp. 272–3.
2. Edward W. Said, *Culture and Imperialism* (New York, Knopf, 1993), p. 32.
3. Edward W. Said, *The Politics of Dispossession, The Struggle for Palestinian Self-Determination, 1969-1994* (New York, Pantheon, 1994), p. 10.

Islam, the Arabs, or the Near Orient'.[1] Indeed, the way Jew and Arab, invented as Semites in European philology as early as the eighteenth century,[2] came to register in the West was best exemplified for Said in an astute aside by Marcel Proust, whom he quotes:

> The Rumanians, the Egyptians, the Turks may hate the Jews. But in a French drawing-room the differences between those people are not so apparent, and an Israelite making his entry as though he were emerging from the heart of the desert, his body crouching like a hyaena's, his neck thrust obliquely forward, spreading himself in proud 'salaams', completely satisfies a certain taste for the Oriental.[3]

Said's interest here was not only discursive but insistently visual. Therefore when in the wake of the 1973 War and the oil embargo, Arabs came to be represented, indeed visualised, in the West as having

> clearly 'Semitic' features: sharply hooked noses, the evil mustachioed leer on their faces, were obvious reminders (to a largely non-Semitic population) that 'Semites' were at the bottom of all 'our' troubles, which in this case is principally a gasoline shortage. The transference of popular anti-Semitic animus from a Jewish to an Arab target was made smoothly, since the figure was essentially the same.[4]

Here, Said begins again with the history of anti-Semitism to illustrate his findings about the history of the Arab, and specifically the Palestinian. To clarify what he means, Said states that in depicting the Arab as a 'negative value' and as 'a disrupter of Israel's and the West's existence ... as a surmountable obstacle to Israel's creation in 1948', what Orientalist and anti-Semitic representations result in is a certain conception of the Arab that is ontologically linked to the Jew; and such a link is made in the visual register as much as in the discursive. Witness his description of this transformation:

> the Arab is conceived of now as a shadow that dogs the Jew. In that

1. Edward W. Said, *Orientalism* (New York, Vintage Books, 1978), p. 262.
2. Following Said's beginning, Gil Anidjar's book, *The Jew, The Arab, A History of the Enemy* (Palo Alto, Stanford University Press, 2002) begins again with European Christian history when the Jew was posited as the 'theological enemy' while the Muslim was posited as the 'political enemy'.
3. Quoted in Said, *Orientalism*, p. 293.
4. Ibid., p. 286.

shadow – because Arabs and Jews are Oriental Semites – can be placed whatever traditional, latent mistrust a Westerner feels towards the Oriental. For the Jew of pre-Nazi Europe has bifurcated: What we have now is a Jewish hero, constructed out of a reconstructed cult of the adventurer-pioneer-Orientalist ... and his creeping, mysteriously fearsome shadow, the Arab Oriental.[1]

In these remarks, what Said is gesturing towards is the endemic anti-Semitism that plagues all representation of Arabs today, indeed the very displacement of the object of anti-Semitism from the Jew onto the Arab. Thus, in light of Said's work, one cannot understand Orientalism, the Arab and ultimately the Palestinian without understanding European Jewish history and the history of European anti-Semitism in the context of European colonialism, which made and make all these historical transformations possible and mobilise the very discourse that produces them as facts.[2] Equally important in this regard is that one cannot understand European visual and imaginary representations of Arabs and Arab geographies outside the modern European ontology of self and other and the European epistemology informing the imagination and the visual representation of these non-European objects of observation.

As seeing is not a simple photochemical response but a hermeneutical exercise, Said delved into the visual question of how he, a Palestinian, can see Palestinians through the eyes of a Swiss photographer. What is inside and what is outside, what is interior (and anterior) to the representation in a photograph and what remains outside it, is where Said located his intervention. While fully appreciative of the aesthetics of photography, Said apologetically justifies the role of the critic as a reader of the social text inscribed by visual representations. For him, Jean Mohr's photographs, around which *After the Last Sky* is constructed, demand an interpretation. In looking at pictures of shepherds and of Palestinian women in the field, for example, Said explains how the process of interpretation begins:

> [The photographs] are all, in a troubling sense, without the marks of an identifiable historical period. And for that matter, they could be scenes of people anywhere in the Arab world. Placeless. Yet all the

1. Ibid.
2. On the transformation of the Palestinian into the Jew, see my 'The persistence of the Palestinian question' in *The Persistence of the Palestinian Question* (New York, Routledge, 2006) pp.166-178.

photographs are of working people, peasants with a hard life led on a resistant soil, in a harsh climate, requiring ceaseless effort. We – you – know that these are photographs of Palestinians because I have identified them as such; I know these are Palestinian peasants because Jean has been my witness. But in themselves these photographs are silent; they seem saturated with a kind of inert being that outweighs anything they express; consequently they invite the embroidery of explanatory words.[1]

Said insists that his reading is one of many and that others can and do read them differently. Indeed, one of first readings of a photograph is giving it a title, such as the one titled 'Shepherds in the field'. Mindful of his Western audience and the influence of Orientalism on them, Said explains:

And you could add, 'tending their flocks, much as the Bible say they did.' Or the two photographs of women evoke phrases like 'the timeless East', and 'the miserable lot of women in Islam'. Or, finally, you could remember something about the importance to 'such people' of UNRWA, or the PLO – the one an agency for supplementing the impoverished life of anonymous Palestinians with the political gift of refugee status, the other a political organization giving identity and direction to 'the Palestinian people'. But these accumulated interpretations add up to a frighteningly direct correlative of what the photographs depict 'alienated labor', as Marx called it, work done by people who have little control of either the product of their labor or their own laboring capacity.[2]

What Said is attempting in piling up possible interpretation upon possible interpretation is to demonstrate the centrality of hermeneutics in making possible not only multiple readings of aesthetic products and their social texts, but the instrumentality and inadequacy of hermeneutics as an exercise in dominating or in resisting domination. Thus he concludes the above paragraph by asserting that

[a]fter such a recognition [that of alienated labor], whatever bit of exotic romance that might attach to these photographs is promptly blown away. As the process of preserving the scenes, photographic representation is thus the culmination of a sequence of capturings.

1. Said, *After the Last Sky*, p. 92.
2. Ibid., pp. 92–3.

Palestinian peasants are the creatures of half a dozen other processes, none of which leaves these productive human beings with their labor intact.[1]

Said is aware of the way in which certain readers of the visual want to insist on only one immediate meaning. Such visual fundamentalists can and often do marshal a theological approach to the visual in the interest of establishing facts and/or of propping up claims. While *After the Last Sky* is an attempt on the part of Said and Mohr to begin again to view Palestinians differently, Orientalism and Zionism had begun almost a century earlier in looking at Palestinians through other visual prisms. Said discusses that 'most famous of early-twentieth-century European books about Palestine', namely the Alsatian Philip Baldensperger's *The Immoveable East*.[2] What struck Said as notable in this inaugural effort was that 'it is magisterial in its indifference to the problems of interpretation and observation'.[3] The same is true for Said of the work of Finnish archeologist and anthropologist Hilma Granquist. Reading these works and 'seeing their photographs and drawings, I feel at an even greater remove from the people they describe ... What I think of when I read ... Baldensperger is the almost total absence of Palestinian writing on the same subject. Only such writing would have registered not just the presence of a significant peasant culture, but a coherent account of how that culture has been shaken, uprooted in the transition to a more urban-based economy.'[4] Said's own book, he felt, was beginning to register such a presence, uncomfortable as it is, both discursively and visually.

Understanding the status of Palestine as historical, Said never reified it: 'The fact of the matter is that today Palestine does not exist, except as a memory or, more importantly, as an idea, a political and human experience, and an act of sustained popular will ... [It is the millions of Palestinians] who make up the question of Palestine, and if there is no country called Palestine it is not because there are no Palestinians. There are ...'.[5] Thus, for Said, to begin with Palestine is to begin with the understanding that 'the struggle between Palestinians and Zionism [i]s a struggle between a presence and

1. Ibid., p. 93.
2. Ibid., p. 94.
3. Ibid.
4. Ibid.
5. Edward W. Said, *The Question of Palestine* (New York, Vintage, 1979), p. 5.

an interpretation, the former constantly appearing to be overpowered and eradicated by the latter'.[1] Said demonstrated his hermeneutical skills as a critic in disassembling the web of representations that Orientalism and anti-Semitism mobilised through Zionism. His attempt to read Palestine from a Canaanite perspective contra Michael Walzer was deeply informed by his interpretative skills. It was not that Said posited some form of perspectivalism reduced to relativism, rather he began by repeating the logic of Zionism to retell its story differently. If Zionism insisted on playing some prehistorical archeological game positing fantastically the ancient Hebrews as the progenitors of modern European Jews, Said smugly posited the earlier native Canaanites, conquered as they were by the invading foreign Hebrews, in ways reminiscent of the Palestinian experience.[2] Polemics aside, and he *was* a master polemicist, Said insisted on revealing that for Palestinians, Zionism constituted but part of the chain of historical invasions of Palestine from the Crusaders to the Ottomans, Napoleon and the British. He insisted therefore on reading Zionism not only in its European environment but also from the standpoint of its Palestinian victims.

But if the struggle over Palestine is a struggle over interpretation, of what lies outside Zionist representations, both visual and discursive, and what lies within them, then the visual, given the apparent immediacy of its images, its apparent independence from the discursive where Said's expertise lies, can only evoke in the literary Said a sense of 'panic' as he once told W.J.T. Mitchell in a now famous interview in reference to the visual arts.[3] There, he reflects on his approach to writing *After the Last Sky*. First Said evokes his own subjectivity, the emotional responses that Jean Mohr's pictures provoked in him:

> I spent weeks and weeks making a selection of the photographs from his enormous archive ... I wasn't really looking for photographs that I thought were exceptionally good, as opposed to ones that were not exceptionally good. I was just looking for photographs that I felt

1. Ibid., p. 8.
2. Edward W. Said, 'Michael Walzer's exodus and revolution: a Canaanite reading,' *Grand Street* 5, Winter 1986, pp. 86–106, and Michael Walzer, *Exodus and Revolution* (New York, Basic Books, 1984).
3. W.J.T. Mitchell, 'The panic of the visual: a conversation with Edward W. Said', in *Edward Said and the Work of the Critic, Speaking Truth to Power*, ed. Paul A. Bové (Durham, Duke University Press, 2000), p. 31.

provoked some kind of response in me. I couldn't formulate what the response was. But I chose them.[1]

Said moved to group the pictures in four distinct piles, which ultimately set the stage for the four-chapter division that composed his book. For him, ultimately, the photographs provided a visual referent to a Palestinian narrative that Said wove around them: 'I was really more interested in how they corresponded to or in some way complemented what I was feeling.'[2] This is not to say that Said thinks the visual and the discursive, or as the interview puts it 'the seeable and the sayable', are reducible to one another, or merely capable of symmetrical representations in different modes. Far from it. Said insists on the 'correlative' nature of the seeable and the sayable 'not in the sense of interchangeable but in the sense of one doing something that the other can't do ... and if you remove one, then something is missing in the other'.[3] Indeed, as I mentioned earlier, Said was most impressed with Foucault precisely because the latter 'would begin with the visible – in other words, it was the visible that made possible the sayable'.[4] Said, however, did not think that the visual should be fetishised or made into an idol to be worshipped. Such fetishisation was directly opposed to his secular commitments. Said's oft repeated citation from the twelfth-century monk Hugh of St Victor is instructive in this regard:

> It is, therefore, a source of great virtue for the practiced mind to learn,
> bit by bit, first to change about invisible and transitory things, so that
> afterwards it may be able to leave them behind altogether. The man
> who finds his homeland sweet is still a tender beginner; he to whom
> every soil is as his native one is already strong; but he is perfect to
> whom the entire world is as a foreign land. The tender soul has fixed
> his love on one spot in the world; the strong man has extended his
> love to all places; the perfect man has extinguished his.[5]

This quotation exemplifies both Said's resistance to nationalist belongings and his insistence on his central notion of 'secular criticism' which allowed him

1. Ibid., p. 35.
2. Ibid., p. 36.
3. Ibid., p. 43.
4. Ibid.
5. Edward W. Said, 'Reflections on exile', in *Reflections on Exile* (Cambridge, Harvard University Press, 2001), p. 185.

to render sayable and seeable much that had been rendered silent and outside the visual frame in the Palestinian experience. Said's project indeed was to make the Palestinian narrative sayable and the Palestinians themselves visible to a world that insisted on not seeing or hearing them. That Said lamented the deafening silence of most American and many European intellectuals on Palestine was very much linked to his insistence that the intellectual must begin and begin again when reading a social, a literary and indeed a visual text. For him, the justice of the Palestine Question would usher in a new beginning, discursively and visually, for global politics, not least because Israel is the last settler colony standing in Asia and Africa.

If Said began with Palestine, he would begin yet again after the Oslo agreement was signed. The importance of new beginnings for him is intimately linked to his aversion to origins. His insistence on the importance of what he called *affiliation* rather than *filiation* mirrored the distinction he drew between beginnings and origins. Thus while Said was filiatively connected to Palestine through the accident of birth, he would later intend willfully to affiliate with it – hence his unwavering commitment to begin again from a new point of departure. For Said, affiliation offers a conscious choice of belonging that filiation simply imposes. While he affiliated with and belonged to the PLO when it represented the Palestinian people's interests, Said disaffiliated from it the moment it abandoned its mission following the signing of the Oslo agreement.

In this sense, Said's notion of secularism, understood as a refusal to believe in infallible gods, not least of which is nationalism and the nation form, is the organising principle for his notion of beginnings and his rejection of origins as theological. Being exiled from dominant ideologies and cultures, including one's own, then, is what provides Said with the tools to be a critic, one that is inside Palestine and outside it, inside the West and outside it, and inside the nation and outside it. This is crucial to his project of being 'out of place', physically and intellectually, and of belonging to certain intellectual and political traditions. Herein lies his sense of belonging to Palestine and Palestinianness, both filiative and affiliative.

This tension between the filiative and the affiliative is what attracted Said to the brilliant work of Palestinian artist Mona Hatoum. In an essay that Said wrote for Hatoum's installation exhibit 'The Entire World as a Foreign Land', an understanding that Said shared, he wrote:

Her work is the presentation of identity as unable to identify with itself, but nevertheless grappling the notion (perhaps only the ghost) of identity to itself. This is exile figured and plotted in the objects she creates. Her works enact the paradox of dispossession as it takes possession of its place in the world, standing firmly in workaday space for spectators to see and somehow survive what glistens before them. No one has put the Palestinian experience in visual terms so austerely and yet so playfully, so compellingly and at the same moment so allusively.[1]

The importance of Hatoum's arrangement of different objects in her installation work, objects that are familiar and utterly unfamiliar at the same time, stems from the way they impress themselves on the viewer:

In another age her works might have been made of silver or marble, and could have taken the status of sublime ruins or precious fragments placed before us to recall our mortality and the precarious humanity we share with each other. In the age of migrants, curfews, identity cards, refugees, exiles, massacres, camps and fleeing civilians, however, they are the uncooptable mundane instruments of a defiant memory facing itself and its pursuing or oppressing others implacably, marked forever by changes in everyday materials and objects that permit no return or real repatriation, yet unwilling to let go of the past that they carry along with them like some silent catastrophe that goes on and on without fuss or rhetorical bluster.[2]

It is this quality of Hatoum's visual art that makes it, as Said asserts, 'hard to bear (like the refugee's world, which is full of grotesque structures that bespeak excess as well as paucity), yet very necessary to see an art that travesties the idea of a single homeland'.[3] For Said, Hatoum's art speaks loudly, as his own writings do, against the ugly horrors of the Oslo capitulation, which American, Israeli and Palestinian plastic surgeons spent (and continue to spend) countless hours in the operating room beautifying: 'Better disparity and dislocation than reconciliation under duress of subject and object; better a lucid exile than sloppy, sentimental homecomings; better the logic

1. Edward W. Said, 'The art of displacement: Mona Hatoum's logic of irreconcilables', in *Mona Hatoum, The Entire World as a Foreign Land* (London, Tate Gallery Publishing Ltd, 2000), p. 17.
2. Ibid.
3. Ibid.

of dissociation than an assembly of compliant dunces.'1 These words of Said are insistently correlative to Hatoum's visual assertions.

In insisting on new beginnings in reading literary and visual texts about Palestine and the Palestinians, Said offered a new language and a new vision, not only to non-Palestinians, but also and particularly to Palestinians, to speak about and see Palestine and the Palestinians from different historical angles and in different geographic contexts. Resisting his initial panic at the visual, Said pursued an engagement with it that uncovered layers of the Palestinian experience that his literary engagement did not permit him to *see*. In his literary works, Said's attention to the Arab and Western contexts in which the Palestinian struggle was waged was the hallmark of his approach. He insisted on reading the European Jewish struggle against anti-Semitism contrapuntally with the Zionist struggle to colonise and dominate the Palestinians, just as he insisted on reading the Palestinian struggle against Zionist colonialism alongside trenchant criticism of Arab regime politics and the politics of the Palestinian leadership. This analysis informed his study of visual representations of, and by, Palestinians, where everyday lived experience as well as the overall political context of the Palestinian condition were being revealed and concealed simultaneously through the power of the visual, wherein in the context of photography, the camera dominates and captures Palestine and its native population while simultaneously showing them to resist its power when they look back at it challenging its attempt to capture them or when they look away from it refusing the very terms of such representations. Indeed, Said's own analysis of the visual is another Palestinian attempt to resist Orientalist and Zionist capturings. His literary studies of Europe and its culture constituted another way where he turned the camera, or more precisely his gaze, back on the Western Orientalists engaged in representing and photographing the non-European. His method of contrapuntal reading has allowed Said to contemplate secular solutions to the Question of Palestine that few others could offer. In seeing Palestine from his standpoint, it becomes clear that Said's indispensable legacy constitutes a new beginning for the struggle to see and speak about Palestine, to belong to the Palestinian idea, to be a critic of discursive and visual representations of the Palestinian experience. It is this legacy from which we can all begin again.

1. Ibid.

The Sharjah Experiment

The 7th Sharjah Biennial

Hoor Al Qasimi

The 7th Sharjah Biennial addresses issues of belonging, identity and cultural location. These are not new issues, but our current culture of mobility, mass migration and so-called globalisation – which threatens the erosion of culturally distinctive places and the international cultural flows of the postcolonial world – makes these issues more prescient than ever. We are now territorialised in a way that has serious consequences for our collective and individual identities. As individuals, many of us are increasingly affected by issues of belonging that are related to geography, culture and borders, the implication being that the link between identity and place has become problematic.

There is at present a new and profound sense of loss of territorial roots, together with the knowledge that when it comes to history, there are no universal truths. In 1942 in wartime Europe, Simone Weil described the need to be rooted as perhaps the most important and least recognised need of the human soul. The uprootedness of migrants, refugees and exiled and stateless peoples has created a new diaspora. Edward Said describes his exile from Palestine as a 'kind of doubleness':

> Instead of looking at an experience as a single unitary thing, it's always got at least two aspects: the aspect of the person who is looking at it and has always seen it, looking at it now and seeing it now, and then as you are looking at it now you can remember what it would have been like to look at something similar in that other place from which you came.[1]

Although this is experienced firsthand by exiled and displaced peoples who suffer from a pervasive sense of homelessness, it is also felt, albeit in a

1. "The voice of a Palestinian exile", in *Third Text*, no.3/4, 1998, pp.39-50.

different manner, by those who live between different cultures. Throughout the twentieth century, the ever-increasing mobility of people around the globe has produced a peculiar uprootedness that consists not so much of lacking roots but of having roots in various places. This is accompanied by the awareness that there is not a unique dominant culture, a centre that gives us an illusion of coherence and provides a calmness to our existence; rather, there exist different ways of looking at reality and different cultures and subcultures that challenge the idea of a seemingly hegemonic culture even within the same geographical space.

The need to search for unity extends beyond the limits established by territory. Multiculturalism challenges and at the same time exhibits the vulnerability of the idea of a unique, sovereign centre, acknowledging a diversity of separate societies, each with its own culture. In this respect, it is worthwhile remembering that the word 'cosmopolitan' originally meant 'citizens of the cosmos' and that it is a concept that emphasises what unites us as human beings rather than the particularisms that characterise our society.

Art inhabits the border and provides a means for exploring and questioning issues at the core of our existence. The main part of the 7th Sharjah Biennial looks at preconceived ideas about identity and place that are assumed in imperial, patriarchal, nationalist or fundamentalist discourses. What does it mean to belong to a culture? What does it mean to speak of 'a culture', 'a people', 'a tribe', 'a nation'? How are the local, the regional and the global interconnected? Can new spatial metaphors convey the new sense of dislocation and displacement that we are experiencing? How do the mass media contribute to an awareness of our fundamental similarities and differences? What does it mean to belong to a place when the majority of us have access to worldwide news and entertainment? Artists may be more concerned with asking pertinent questions than with offering definitive answers.

Our thanks must go first and foremost to the artists participating in the 7th Sharjah Biennial. Their willingness to share their work with us has placed great demands on them, and we very much appreciate their generosity. We extend our grateful thanks to the curators and coordinators, without whom this project would not have been possible. We acknowledge with gratitude the editors, authors, translators, designers and the many other people involved in the production of the biennial catalogue. To

the many departments of the government of Sharjah, in particular the Cultural Department, I would like to record here my appreciation of their commitment. Finally, we would also like to thank the sponsors for their much-needed support for our programmes.

A Place to Go

Jack Persekian

'Where are you from?'

This is often the first question I am asked when I travel, and since I am away from home a lot of the time, I hear it quite often. Sometimes I am tempted to answer in the words of our national poet Mahmud Darwish, who wrote 'my homeland is my suitcase'. After all, my home and belongings often seem to be restricted to what a suitcase can hold. But that is not all.

The question of where I come from or where I 'belong' deserves more thought. To say that I come from Jerusalem and that Arabic is my mother tongue only raises further questions for those who inquire. At times, these questions involve my name. Having the first name Jack, for example, intrigues some people. To them I want to say that names, like memory, may be embedded in their own history. When it comes to my Armenian family name, I hardly ever mention that it is spelled and written by my Arab compatriots differently from how the name actually sounds in Armenian. Traditionally, 'Persekian' – literally 'son of Persek' or 'from Persek', a town in Turkey – when spoken or written in Arabic becomes 'Barzakhian', which I understand connotes a totally different meaning.

A friend once joked that the way fellow Palestinians pronounce my family name represents who I really am and what I am doing, because the Arabic word *barzakh* has multiple meanings that all relate to states of being 'in between'.[1] Perhaps that sums up where I belong. After all, when I am not somewhere in between airports, I work in multiple places in between artists and cultural institutions, and when I go home it is to the city of my birth

1. See in this volume Nadia Tazi's reference to *barzakh* p. 112. [Editor's note].

which has been divided between Arabs and Jews. Today I do my business in Arabic and in English, and I have always lived between written and colloquial Arabic. I was destined to live somewhere in between my Armenian origins and my Arab identity, being born to a Christian family and belonging to an Arab Muslim culture.

Coming of age in Jerusalem meant growing up hearing and speaking more than one language. Arabic is my mother tongue, but as far back as I can remember, Armenian, English and French were always present during my childhood. My identity as a Palestinian was shaped by all the languages I heard in my youth.

When I say my mother tongue is Arabic, I mean it literally. It was my mother, a Palestinian Arab, who taught me how to express myself in Arabic. The Armenian I know comes from my Armenian father, from whom I inherited the name Persekian, that of a Jerusalem family whose roots in the city span many generations.

It may not be well known, but Armenians settled in Byzantine Jerusalem in the fifth century, that is, two centuries before Omar ibn al-Khattab set foot there. Thanks to him, Jerusalem became an open city, home for all its citizens regardless of their sect, ethnic origin or religion, be they Jews, Christians or Muslims. The history of Armenian families like mine who remained in Jerusalem throughout the thirteen centuries of the city's Islamic history is a living tribute to that heritage.

In 1967, when the State of Israel annexed the Arab sector of Jerusalem and declared the city to be 'eternally united', Jerusalem became more divided than at any other time since the Palestinian débâcle. Overnight the Israelis stripped Arab natives of Jerusalem, like myself, of their birthright, turning Christian and Muslim Arab Palestinians into aliens in their own home. The city is now claimed to belong exclusively to its Jewish conquerors. Israeli law considered us no more than residents in our city of birth. Residency permits were granted to us, and we were told to carry them always. These documents could be revoked at any time at the whim of an Israeli official. More recently, we must also contend with the separation barrier that not only cuts off Jerusalem's Palestinians from Palestinians living in the West Bank, but also separates Palestinian communities within Jerusalem from each other. There are cases in which members of the same family have been made by Israel to live on different sides of the barrier.

Where do I come from and where do I belong? I know where I am from and I know where I belong, although I may nevertheless spend the rest of my life living out of a suitcase. Places that others call home are there to be shared by nomads like me.

I attribute my fascination with travel to my father, who belonged to the last generation of traditional bookbinders operating in Jerusalem's Old City. It was in his workshop near the New Gate that my dream of travelling first took shape.

His craft gave a new life to old books, and a magnificent new world unfolded before my eyes. Over the years, it was through art that I found the boundless horizon I sought. Even though my pursuit entailed a host of uncertainties, it nevertheless evoked a passion that would become a driving force of exploration, of which I would never tire.

To set sail, I turned my father's bookbinding workshop into an art gallery. The Old City was dying, and I only wished I could contribute to its people by sharing with them works of art that allow everyone to fly beyond the walls surrounding them. Connections needed to be made, voices needed to be heard, and most important, opportunities and resources needed to be provided for art to happen. Thus a window was opened onto the international art scene from a tiny gallery on the front lines of an unwieldy conflict through connections made during the first Gulf War, a time when the eyes of the world focused on the region.

Working with local and international artists on new projects became my obsession, and finding connections between their work and the contexts in which they were conceived – in this case, Jerusalem/Palestine – was the principal focus of my curatorial work. The artists' interest in a dialogue with an environment, a situation, combined with my enthusiasm for a visual/conceptual discourse with the place, the people and the politics, provided the ingredients for realising works addressing social, political and humanistic issues from firsthand experience. As today's Jerusalem became less open and more constricted than the Jerusalem I had previously known, I felt the need to let the world in, to welcome artists from other countries so that new blood could be injected into the Palestinian art scene. I could cite a long list of artists and works of profound influence, but for reasons of space will limit myself to just a few: Jean-Luc Vimouth's *Café de l'Olivier*; Mona Hatoum's *Present Tense, No Way, Lillie Stay Put*; Jean-Marc Bustamente's *Something is*

Missing – Suspension; Beat Streuli's *East Jerusalem*; and Emily Jacir's *Where We Come From*.

On my first visit to the United Arab Emirates I was struck by the dichotomy between the scale of expanding urbanism and the nature of the environment in which this growth is taking place. One remarkable feature is the contrast between the expanse of the desert and the concentration of high-rise buildings in a small area near (and increasingly on) the sea. Another is the proliferation of artificial and exclusive environments devoid of any reference to the local heritage. This reality forms the backdrop of this exhibition and the personal encounters one makes once there; it is also both the material and context for many of the artists invited to participate in the show.

Interestingly, Sharjah (the Emirate and the city) positions itself as a place of memory through the formulation of its identity, which is reflected in the exceptional patrimony of heritage buildings, which, in turn, prompted UNESCO to name Sharjah a cultural capital. Yet it is quite obvious that the majority of the population does not really 'belong'.[1] They are passing through, their sojourn a phase in their life, in which they pursue the dream of securing a better future for their families back home. This flux of populations – urban-rural, across borders, desired or forced – so characteristic of modernity, often implies a search for radical alterity or a sweeping loss of identity. When locality, which sets norms and determines a variety of references, loses its potential as a harbour of safety, the strange new world of exile can bring about a reversion to polarised positions conditioned by mental restrictions that tend to apply constricting labels. Alternatively, it leads one to create, for one's self or one's group, a virtual home within exile. There is an entire media and an array of sprawling developments in the Emirates put to the service of this imagination.

As such, the context, the environment and the temporality of life in Sharjah provided an ideal set to reflect on shifting interpretations of identity, home and land, territory, ethnicity, exile, loss, assimilation, contemporaneousness and so on. Tackling these issues head on in all their

1. About 80 per cent of the population of the UAE of some three million people are expatriates.

complexity, taking stock of political, economic, sociological and cultural contexts, the 7th Sharjah Biennial was an attempt to transcend locality, hoping thereby to shed new light on the elusive subject of 'belonging' in its many manifestations.

In hindsight, I confess that I would have preferred to forgo the thematic curatorial framework set by the biennial format. Although I still find the overarching theme of the event – 'belonging' – to be an extremely compelling and highly relevant concept, the creative imagination, it seems to me, must be given total freedom. Edward Said argued that there are no rules by which intellectuals and artists can know what to say or do.[1] Hence my mission to set up this biennial as a unified – yet liberating – display was a challenging one, because the territory is not only diverse, but also difficult to negotiate.

The history of the world through visual imagery and representations was (and still is) written by the West. The image of the East – as Said's *Orientalism* taught us well – was also formulated by the West. Today's particular prejudiced vision of the Orient is merely a trajectory of what has been passed on from the times of European colonialism and its Orientalist escapades and flights of fancy. The narrow stereotypical prism through which a Westerner imagines the Orient is being perpetuated today through the media. Yet the means of production and promulgation at the disposal of the media conglomerates, and their mass dissemination capabilities, frame the East in a distinct, static and distorted manner. The East and South are at a loss here, for they lack both the capabilities and possibilities of controlling the image production processes, which portray and represent them, and the means and know-how to produce their own set of images and representations. Hence, this portrayal is relegated to the merciless and all too powerful professional image-makers, who serve only their patrons.

The artists who have come to Sharjah have ventured out of the confines of normative representations and have allowed themselves to explore the ever-shifting topography of belonging and non-belonging. Mobility is imperative to their endless pursuit of transformation and change. They have developed a total disregard for boundaries, which are, as Arthur Danto asserts, 'the domain ... of armies and of customs officials.'[2] Their mission has shifted in recent years

1. Edward W. Said, *Representations of the Intellectual*, The 1993 Reith Lectures (New York: Vintage Books, 1996) p. xiv.
2. Arthur C. Danto, *Art and the Discourse of Nations: Reflections on Biennial of Nations*, 4th Biennial of Istanbul catalogue, 1995, p. 57.

from one of subjectivity to one of social consciousness. Artists have become observers and, willingly or unwillingly, postulants for a redefinition of the dynamics that drive society at large. Their position is no longer a romantic or heroic role. Some have experienced displacement and alienation, a context which provides a niche of some significance from which to address issues of identity and belonging and to challenge inherited notions of home, territory and ethnicity in a world constantly shifting.

Artists position themselves above the confines, limitations, restrictions and taboos of societies. Their work can be contagious, and to some it can be threatening. 'Beware of artists,' Queen Victoria once said, 'they mix with all classes of society and are therefore most dangerous.' These artists, who are often vocally critical of their own societies, have contradictory allegiances. They would seem to be living on the limits between opposed communities or groups, and their very being might be said to traverse religious, ideological, ethical and other fault lines. I am referring to artists whose works embody certain critical attitudes towards our very existence – artists who articulate beauty and pain, desire and destruction, transgression and righteousness, for the sake of reconstructing an individual as well as a collective identity; artists who engage in existential issues of life and death and political activism. It is this critical and in-between state of existence that brought them together to an in-between place. This place – Sharjah – is not super famous and may be considered by many the hinterland of the art world.

Yet the Sharjah Biennial 7 tried to capitalise on the opportunity provided to initiate and facilitate the creation of new projects. It encouraged and invited most of the participating artists to visit Sharjah before they sent in their work so that they could develop proposals based on the actual (physical) encounter with the context of the show – its theme, its venues, the local culture and the time/place element. This not only enriched the show with works that had engaged with the local in some sort of meaningful dialogue, but also provided some of the local and regional artists with much-needed resources and means to produce and experiment with new ideas. This opportunity has proven to be unique in the region, prompting Kaelen Wilson-Goldie to conclude in her review of the Sharjah Biennial 7 in *Flash Art* magazine that

> The most crucial and enduring contribution this event has made to
> the region's mechanisms of cultural production comes from the fact

that the Biennial commissioned no fewer than 20 artworks, in many cases inviting local, regional and international artists to spend time in Sharjah producing new projects. In the absence of a viable public, the Sharjah Biennial may end up evolving into a kind of independent laboratory for artistic and intellectual inquiry. If it does, Sharjah will be the first of its kind.[1]

Here, I would like to address three particular works that are representative of some of the ideas and issues I wanted to tackle in the show. The first is Olaf Nicolai's 'untitled' project. His concept stemmed from the conscious urge (of an enlightened Westerner) not to fall for preconceived notions about the Arab world; of the need to constantly remind oneself (particularly for one coming from exclusively Euro/Western culture) that many of the images of the East are Western fabrications spiced up in order to feed the lust for an exoticised Orient. His idea was to reverse this notion and bring in to the East, to Arab society, a constructed stereotypical image of a Western society. For this he chose Italian cinematic depictions of a stereotypical Italian street. He in fact went to Italy, and brought back to Sharjah the hanging laundry and the laundry ropes and pulleys that he saw in the streets, and erected them in between the two buildings of the Sharjah Art Museum. The impact of this work in Sharjah and the Emirates was immense, since it not only became an instant attraction, it also stirred up controversy and debate in the local press. As the reader is probably aware, laundry in the Arab world (and I'm generalising here, for there are exceptions) is considered private and it is not customary to exhibit it in public, particularly in the Gulf region. Their traditional houses (and of course their modern ones too) are constructed with high walls that surround the house, with only inconspicuous openings. Inside, there is normally a private courtyard surrounded by various rooms, and the laundry is hung out within this private space, visible only to the household members. In the Emirates (naturally, I would say) there is a law that prohibits the drying of laundry on windows or anywhere else visible from the streets or in public. So when people saw the washing hanging in such quantities in the middle of the town and in such quantities, some were completely shocked and some were appalled to the extent that they called the municipality to draw their attention to this aberration. Crucially, the artist's response to the context of the Biennial – and to the theme I wanted to focus

1. Kaelen Wilson-Goldie, *Flash Art* issue of May–June 2005.

on with all the underlying issues of identity, representation, preconceptions and misconceptions – was thus poignant and articulate. At the same time it was a pleasurable spectacle (which is what the audience expect from an artwork). And so, in my opinion, the artist in this case had managed to subtly undermine the prejudices that fuel the formulation of distorted notions and images about a certain people, region, culture, race or creed by critically subjecting a typical image of an Italian street to ridicule from a society which considers this street laundry decor as shameful and simply not done. The Sharjah Biennial, as I see it, has played a very important role in reversing that notion by becoming a place of production, 'a laboratory for artistic and intellectual inquiry',[1] and source for inspiration and the creation of images, ideas and critical discourse, thus undermining that same argument I made at the beginning of this essay, that 'the image of the East – as Said pointed out – was formulated by the West'.[2]

The second presentation I would like to discuss involves two works that are exhibited some five kilometres apart, yet to the spectator with a keen eye for detail a connection between the two can be detected and some sort of loosely held dialogue is traceable, which forms the fine thread line that runs through the whole show, weaving it into a fabric of varied manifestations, techniques, materials, ideas and concepts under the theme of 'belonging', with which I had never intended to sum it all up. One work, *Embrace* by Emily Jacir, is an airport baggage conveyor belt made into a circle 175 cm in diameter (the artist's height), which I placed right at the entrance of the show in the large Expo hall. The other work is by Zoe Leonard, entitled *1961*. It consists of forty-two pieces of vintage luggage items lined up in one row as if they had been waiting (for a very long time) in the 'lost and found' for their owners to come and pick them up after a long journey, and which I placed right at the very end of the long trajectory in the second museum building. So when you enter and leave the show you are reminded of travel, mobility, being away from home, instability, displacement, exile, refugees – reminded of where you are and where you belong. *Embrace* (the luggage conveyor belt) operates the moment a person approaches it, and stops when that person moves away from it. It turns around itself in a clear reference to the notion that we are going nowhere. But should that be seen from a

1. Ibid.
2. Said, p. 134.

positive or a negative perspective? If you are in a Third World context and considering your children's future prospects, I can sadly say they are going nowhere. But if you are the underdog being pushed around and gradually away to make room for the rich and the occupiers, there's a clear statement there: 'we're going nowhere, we're staying'. *Embrace* allows us to rethink our modern fascination with travelling, immigration and going to other places in the world in search of a better life. As I pointed out above regarding my encounter with Sharjah and the make-up of the society there, this work, as it turns around itself pointlessly representing futile effort, somehow alludes to the dilemma of many of those migrants living temporarily in places trying to save money for their retirement or to bequeath to their children. They have to face an ever-increasing cost of living, skyrocketing prices and the hard truth at the end of every month of having barely broken even or worst still of having accumulated debt after falling for the temptations of consumption and easy credit. *Embrace* speaks abundantly of the type of life led by several migrants I have met, who somehow feel trapped between the fact that they are not getting ahead as much as they had anticipated when they started their journey away from home, and who fear the unknown – what life is going to be like if they try to go back to where they came from. There is also the psychological trauma of returning to square one, of having uprooted themselves (and sometimes their families as well) for a better deal and having spent all those years in vain.

A place to go

Yet we never cease to be fascinated with travelling. We wander out. We leave the place where we have interwoven our being with the physical environment and the myths, and we reconstitute a new reality through memory, language, objects, practices, ceremonies and familial and friendship ties. As we become aware of our new unhinged reality, we try to gather the fragments that have fallen between the cracks, left behind at some point during a frenzied departure, when scandalous secrets are shredded and overweight luggage is offered up at airport check-in counters. These fragments and forsaken belongings help us appropriate new habits and practices that we remould to add new dimensions to our experience.

History betrays us, for we are not the ones writing it; we are the ones

who remained on the wrong side of the fence, so to speak, listening in on the discourse about the clash of civilisations gaining momentum in the media and on the ground and witnessing none of the anticipated departure from the *status quo ante*. We reflect in our dreams the images of a forgotten yet cherished past that echoes with cynicism at the situation in which we find ourselves. It is not so obvious to many that this echo merely alludes to an imaginary world of concentric centres with contiguous peripheries. The reality is that the world is a multiplicity of centres pulling and tugging in different directions, and at the seams chasms eradicate life, leaving behind unfulfilled dreams and tattered diaries strewn in the hinterland.

By leaving behind past answers and unexamined certainties, which are part and parcel of our background, language and nationality, and which so often shield us from the reality of the other, many of us never seem to be content with the answers given to the question 'Where do you belong?' and end up searching for another place to go.

Unfolding Identities

Ken Lum

In recent years, it has become *de rigueur* for major art exhibitions that survey large swaths of global art developments to draw parallels between the nomad as a figure of creative resistance and the cultural figure of the artist. The dissemination of contemporary artistic interest worldwide signals a decentralisation from a more historically particularised and syndicated understanding of art to one that has seen a shift of emphasis from aesthetic concerns to social issues, from static to temporal processes or events, from object-oriented to site-specificity, and from art that is declarative to art that can double as non-art. In conjunction with social and political activism and emergent anti-imperialist movements, critical practices and institutions are looking for new modes of production and participation and new spaces of critique in the overlapping fields of culture, urbanism and politics. Notably, conceptual artists have extended the reach of art into multiple and overlapping public and private domains, with art taking multifarious forms and penetrating many media and channels, including Internet and community-based practices.

It is understandable that as the world shrinks ever faster, the trope of the nomad has become increasingly popular in terms of lending theory to emergent forms of deterritorialised and delocalised social movements and neo-tribal collectivities. Mobility in the form of human migration and communication (that is, the rise of mobile telephony) signals the potential for a new radicalism that can challenge what Henri Lefebvre called the 'representations of space'.[1] For Lefebvre, such representations of space meant

1. Henri Lefebvre, *The Production of Space*, tr. Donald Nicholsan-Smith (Oxford and Cambridge, MA, Blackwell, 1991), pp. 38–9.

the encoding of hegemonic power into the built environment so as to be experienced by the individual as a disembodied and naturalised assemblage of segmented, spatial spectacles.

The channelling of nomadic movements by the state, institutions and other dominant forces is challenged by the metonymic power of the rhizome, what Gilles Deleuze and Félix Guattari saw as endlessly creative, decentering and variegating sets of machinic assemblages with the capacity for new and often provisional collectivities that can escape and even break down processes of encoding and enframing. 'How many people today live in a language that is not their own?' asked Deleuze and Guattari in *From Kafka: Toward a Minor Literature*.[1] In other words, how many people lead lives that are able to transgress the delineations between theory and reality? Confronted by codes of 'language, literature, thought, desire, action, social institutions, and material reality', the nomad is protean in its adaptive capacity and signifies a subversive force from within any system with the aim of, as Deleuze and Guattari famously said, secure 'c'est de sortir, c'est d'en sortir'.[2]

According to Homi Bhabha, the nomad is an 'unfixing' figure, as much a traveller of undetermined movement as a tropic figure of critical exile from the rigidities of imperialist categories.[3] Nomads in the form of immigrants or refugees are impervious to borders, not necessarily by choice, but often by lack of choice; the barriers of containment nonetheless heavily mark their transgressive bodies. Nomads operate at the thresholds of space and politics, language and power, and in so doing, constantly negotiate and produce new concepts of transcultural identities, both personal and collective, that are destabilising to established orders, systems and codifications.

Mobility, for Arjun Appadarai, has become an emblematic concept of life within the globalised world, understood in fluid terms of cultural 'flows' and 'scapes'.[4] Mobility is conceived of in all its aleatory complexity, from diasporic movements to the circulation of resources and ideas. But nomadology, in the truest sense, is available not only to the poor and those without official papers; it is even more accessible to the privileged and the powerful. This is

1. Gilles Deleuze and Félix Guattari, *From Kafka: Toward a Minor Literature* (Minneapolis, University of Minnesota Press, 1986).
2. Ibid.
3. Homi Bhabha, *The Location of Culture* (London and New York, Routledge, 1994), pp. 1–18.
4. Arjun Appadarai, *Modernity at Large: Cultural Dimensions of Globalization* (University of Minnesota Press, 1996).

an often under-considered aspect of much of the writings about nomadic resistance, lending such writings an air of idealism and/or abstraction. In this cat-and-mouse game played between containment and elusiveness, the winner is overwhelmingly the cat.

The forces of globalisation are not total. Nor are they isomorphic. Rather, they are full of disjunctures in which meaning and identity are regrounded as much as they are uprooted. While much has been written in terms of the potential of radical democracy to form at the level of an individual's localised relationship to structures and processes of dominant power, issues of longing and belonging, of a desire for attachment, have been de-emphasised. Longing and belonging compel the nomad; they are not exclusively terms attached to notions of stability and rootedness. Here it is worth recalling Antonio Gramsci's famous theory of hegemony and the ambiguous desire on the part of individuals to be accepted within the norms produced and perpetuated within a social order that often operates in their disfavour.

Nomadology as a tool for theorising the multiple means by which travelling individuals negotiate and renegotiate subject positions in the context of codifications of family and community groups, gender, skin colour, economic and social class and nation-states is useful but problematic in terms of the often devastating psychological and physical damage borne by these same individuals during the very process of negotiating subject positions. Deleuze's idea of 'limitless postponements' of postmodern 'societies of control' seems utopian, since 'limitless postponements' themselves are configured as stratagems of control.[1] Stress, social loneliness, feelings of exclusion, powerlessness in the sense of the inability to control or even have a say in one's own future, physical duress, lack of education or under-education resulting in a deficiency of skills, hunger and illness are all characteristics of the experiences of the poor. Poverty and other examples of global distress are as much a multifarious and rhizomic condition as they are an expression of containment and control.

Many artists have responded to the problems of global social problems by adopting a documentary model of practice, a model that further destroys, at the very least, the conventional distinctions between art and non-art. At the same time, there is a pedagogical (and even a shock aspect) to the documentary art so prevalent in such seminal exhibitions as *Documenta*

1. Gilles Deleuze, 'Postscript on the societies of control,' *October*, no. 59, Winter 1992, pp. 3–7.

XI. The shock is not the modernist shock of the new but the shock of recognising the complexity and diversity of social experiences and subject matter in the world to which art, confined largely to Euro-American terrain and perspectives, have until recently failed to engage.

Until recently, an obstinately normative narrative continued to push to the margins artists of difference, such as women artists and artists of colour, from the vast expanse of the developing world. Criticality in art was highly circumscribed by the prevailing Euro-American codes of art historical understanding, not by the politics of difference with its intersections with postcolonial, feminist and anti-racist debates.

The forces of globalisation have pushed to the fore issues of identity as they relate to geography (or locality), politics, history and questions of ethnicity, gender and race. But they have also propelled the global oligarchs to map the world according to their desires, to assert their will over the world's resources and its many exploitable peoples. The playing out of cultural symbols and histories, the delineations of various group and ethnic definition and assimilation, and the interplay between traditional and modern concepts of identity and space are also key concerns. Questions of constitution regarding disciplines by methods of interdisciplinarity are creatively examined by many of today's artists. And that is to be expected, for it is through the various group identities of difference – identities that elude the development of rigid definitions – through their very bodies, such diversely rich ideas for the enactment of new political analysis can eventuate.

Issues of exclusion and cultural marginality are particularly resonant today in the Arab world, as is the supposed incompatibility of religious traditionalism with secular enlightenment and modernity, which provides the pretext for imperialist enforcement in Iraq. The Emirate of Sharjah, recognised by UNESCO as one of the world's great cultural heritage sites, is located at the crossroads of one of the world's most complex geographic intersections. In terms of the United Arab Emirates, Iran and Iraq sit to the north; Pakistan, India and China to the east; Saudi Arabia to the south; Israel, Palestine and the continent of Africa to the west. The orbit of departure and arrival into the United Arab Emirates is just as likely, if not much more so, to be Delhi, Colombo and Addis Ababa as it is Paris, London and Rome. The world beyond the so-called West is full of such orbits, which are scarcely thought about let alone imagined to exist as anything worth knowing except

to serve as alimentation for further Orientalism.

The heritage emirate of Sharjah makes for a particularly fecund heterotopic space, a 'counter-site', as Michel Foucault defined it in his 1967 lecture entitled *On Other Spaces* (my mind deviates to Robert Smithson's notion of a non-site), in which 'the real sites, all the other real sites that can be found within the culture, are simultaneously represented, contested and inverted'. Such sites would include the complex ways in which modernity and traditionalism co-exist that, according to Foucault, presuppose 'a system of opening and closing that both isolates them (as heterotopias) and makes them penetrable'.

In recent years, Arab intellectuals from Edward Said to Mohammad Abed al-Jabri have offered radical new perspectives that find in the past the basis for a pluralistic exegesis of the Arab context today. The geopolitical location of Sharjah, within a framework of rich cultural heritage and contemporaneity, provides a diversity of openings for intellectual dialogue and creative activity. Within the considerations here outlined, in a culture rooted in actual nomads and Bedouins, and not just metaphorical ones, there is much dramatic evidence challenging the most entrenched preconceptions of what it means to actually experience and partake in the offerings of this part of the world.

The problems here are global in scope, albeit more underlined in terms of questions of religion, gender and Arab identity: the struggle of self-affirmation, of the maintenance of tradition in terms of a historical rather than ahistorical reading; of an engagement with the West in a manner not philologically and methodologically Orientalist but mutually contributive; of negotiating the flows of globalisation with regard to the interplay of local, regional and international considerations in ways which are not merely assimilative of Euro-American values but permissive and acknowledging of natal perspectives.

The Sharjah Biennial offers a unique context for artists to fill their symbolic roles as nomads and contribute to the creative and intellectual dialogue ensuing in this vital and often misunderstood region of the world. The distrust of art as a function of institutions, so common in the Euro-American context where the administration of art is more developed, that is, where the political economy of the art world maintains the categorical status of art, is extremely developed, is less germane in Sharjah where contemporary

art is less enfolded within an art system.

On the contrary, art can be more greatly empowered in such a situation; in effect, it can repair its earlier vital role, away from the emasculating context of the Euro-American situation where irony often offers the limits of critical expression. Art can bear content more complexly, if not necessarily more freely; it can offer meaning, experience and emotional effect. What Raymond Williams called 'structures of feelings', that is, issues of friendship, happiness, longing and belonging, art can imaginatively and politically help in the understanding of the world. In Sharjah, as in other sites of the so-called periphery, art can rediscover its collective impulse, as a practice of critical reflection and longing.

I would like to add a few personal words. It is a cliché to say, but art is indeed a voyage of discovery and self-discovery. As an artist, I have found both discovery and self-discovery in extending my practice to beyond just making my own works of art for exhibition. I have found that the true heart of art beats strongly in many parts of the world, often more strongly than in the so-called centre, and often it does so in the furthest reaches of the world, places such as Senegal, Mexico, Nigeria, Indonesia, Brazil, Cuba and many other points of the so-called periphery. Being an artist often means a life of non-identity with one's environment. Artists also long to belong, but the curse and saving grace of art are that it can never belong.

More than a Feeling: Issues of Curatorial Criteria

Tirdad Zolghadr

If you were trying to piece together an international biennial, would you prioritise regional artists for the sake of creating a long-awaited platform, or would you scoff at the tokenism of such gestures and emphasise the global artscape? And if you opted for the latter, would you embrace it with pristine enthusiasm, at the risk of looking like a global village idiot, or would you be suave and pick carefully from the lip-smacking discursive smorgasbord of critical approaches, ranging from postcolonial routines to relational aesthetics to individualised exercises in self-reflexive trauma, and so on? Among the many intriguing dilemmas that arose with the speedy preparation of this exhibition – and in view of chief curator Jack Persekian's choice of the biennial theme of 'belonging' and the unusual situation of a freshly reconceptualised Emirates biennial – these questions were particularly relevant.

'Belonging' is not necessarily a question of identity politics or geopsychology; it also bears on the context of growing professional ambitions and the anxieties that follow. What does it take for a biennial participant to be invited to the gala dinner in the Grand Ballroom of International Art Inc.? What, in the first place, are the reasons for the boom in large-scale events over the past decade, and what are the demands that are catered to? Is a biennial necessarily a decontextualised drive-in consumer service, or is it more aptly described as a ready-made, an instant coffee, of the arts industries? Personally, I have no qualms about the mainstream avant-gardism of recent biennials, nor do I believe smaller is better, or that more local is better, but this hardly means Sharjah does not have its own unique selling points to nurture, nor that it should embrace internationalism with the fervour of a young hippy.

No matter which thematic etiquette is picked for the Sharjah Biennial, be it 'belonging', 'unbelonging' or 'space oddity', it would be engulfed and conditioned by the specific biennial format, that is, by the international horizon of audience expectations, the postregional/quasi-global criteria, the inevitably hair-raising logistics, and all the other microtraditions of aesthetic prerogatives, tacit hierarchies and intellectual creature comforts that mark the latter-day version of 'biennalicity'.

In sum, the reflection on the international biennial format was my main curatorial preoccupation here, encouraged as I was by the plethora of discussions that have been evolving around the issue of late. If I felt that Sharjah could in some way contribute to this burgeoning discussion of the biennial phenomenon, it was partly by striving for a maximum proportion of site-specific work on display and by persistently reminding the artists (and myself) that the 'site' was not only an urban sprawl in the Gulf area, but also a semi-transposable arts occurrence – that is, that it was not, as far as our particular role in this particular event was concerned, a town in the Emirates as much as an apparatus running on political goodwill, urban marketing aspirations and cultural capital. In the context of the biennalicity symposium that took place during the opening days of the exhibition, I invited Dirk Herzog, an artist who has worked on the tropology of tourism, to document the Moscow Biennial as a point of comparison. Moscow has both a larger art scene and a more illustrious team curating its biennial, and yet it seems just as oddly unpredictable, idiosyncratic and thus *simpatico* as Sharjah, making it an unlikely but fitting sister biennial of sorts.

It so happens that a number of artists I invited – including Luchezar Boyadiev, Pio Diaz, San Keller, Santiago Sierra and Carey Young – often use *in situ*, performative interventions as a medium. It is true that performance offers the possibility of exploring a biennial as a 'process', even as an 'open-ended' situation potentially transgressing the boundaries of art, but since these idealistic formulations – currently advocated by the most brilliant minds in contemporary curating – are rather obvious examples of academic folklore, perhaps one might prefer to consider a performance in Sharjah an opportunity to highlight, rather than play down, the limits between the privileged discourse of the art world and the realm of the profane. Quite often, it can also function as a shrewd commentary on the, shall we say, 'ephemeral' aspect of most biennials, or indeed of most exhibitions worldwide, on the

fact that almost all visitors drop by only during the preview, when the place is packed, and the artworks barely visible. This proves once again that the consumption of contemporary art is first and foremost a social affair, while the aesthetic experience is clearly a welcome side effect. Moreover, performative work opens a space of comparative liberty allowing artists to react to the setting without fear of interference from any side, be it curatorial or other. And finally, very often, the undercurrent of embarrassed tension that is part and parcel of most performances is a good way to find out whether the crowd has a sense of humour, which, in turn, will say a lot about the biennial at large.

In the above spirit of site specificity, the film-maker Solmaz Shahbazi, one of the directors of the award-winning documentary *Tehran 1380*, was invited to represent the political patron of the biennial, the Ruler of Sharjah, H. H. Sheikh Sultan bin Mohammad Al Qasimi, by means of a video portrait. In some ways, my suggestion to Solmaz Shahbazi was also a roundabout, an uneasy, reaction to widespread hopes that the biennial should address 'regional' realities. In the light of these same expectations, I found it appropriate to work with artists who addressed issues such as Palestine and Israel (Solvej Dufour-Andersen, Nedko Solakov), the archaeological pillaging of Iraq (Christoph Büchel, Giovanni Carmine) or the oil economy (Natascha Sadr-Haghighian), but from a perspective that was unmistakably eurocentric and removed, rather than sympathetic and/or ethnographic.

On that note, to counter the routine allegation against group shows, that of the thematic straitjacket, allow me to clarify that this was only one of the aspects that interested me in the above-mentioned projects, and that, say, Sadr-Haghighian's contribution can just as well be regarded a take on 1970s developments in art practices and commodification, as a mere historiography of the politics of the crude. On the other hand, the work of Shirana Shahbazi and Kelley Walker, for example, who both grapple with traditions pertaining to Western iconography, shall, for better or for worse, gain in new-fangled and indigenous connotations once they are seen in the Sharjah setting. The same, I presume, goes for IRWIN's restructuring of several diagrammatic pieces for the biennial, artworks that are genealogical musings on their own art-historical terms of possibility, and reflections on the very possibility for an artwork to portray these art-historical possibilities as such. Since IRWIN has wryly staged these genealogies to suggest that they exemplify a distinctly

'East European' perspective, the comparative potential in a place like Sharjah
is as bracing as it is prone to misunderstandings.

When faced with the challenging notion of belonging in the context
of the Sharjah Biennial, it was my research on ethnic marketing that first
came to mind, a concept I had worked on for two years as the title for a
collaborative project culminating in an exhibition at the Genevan Centre
d'Art Contemporain. The exhibition was an inquiry into contemporary
modes of xenophilia in the international art market, the growing interest in
art from the South and the East. The exhibition tried to argue that the West
was not a polite observer of globalised cultural flows, but actively defined the
supply, just as any other demanding client. In sum, the objective here was to
reconsider the traditional object of research and discovery: if there is a place
that still needs to be scrutinised, regionalised, provincialised, strategically
essentialised as such, it is hardly the South or East, but the fountain and
high-ground of ethnic marketing, the West itself. Here in Sharjah, a number
of the artists in the Geneva show, including Leyla Al-Mutanakker, Ursula
Biemann, Com & Com, Peter Stoffel and Erik van Lieshout, were invited to
rephrase their working premises according to the new context.

As Carlos Basualdo recently pointed out, at the end of the day, when it
comes to any innovative or critical input, the most convincing options still
open to a curator of any biennial are nothing new, nor spectacular, nor even
poignant. For one thing, there is the critique of the canon, a critique that is
largely an old-fashioned engagement with non-canonical names and ways
of doing, but also of showing the ways in which the modes of organisation
of knowledge that structure the said canon are ideological and jerry-rigged.
Second, the curator of a large-scale event is in a relatively good position to
test the limits of predominant concepts in present-day art practices, mana-
charged buzzwords just as well as settled terminological monuments, be they
'site-specificity', 'institutional critique', 'globalisation' or the artist's personal
'background'. Interdisciplinarity – a catchword that is much more workable
since losing its buzz over recent years – is only one way of coming to terms
with this. Beyond engaging with cultural workers willing and able to dabble
in outlandish professional waters (bringing their quirky understanding of
buzzwords and terminological monuments with them), interdisciplinarity
can be an issue of framing artworks, or any curatorial, scenographic, academic
and architectural contributions, in a manner that raises questions as to the

definition of the very genre they represent, and the strategies of *mise en scène* traditionally underlying them.

In Sharjah as elsewhere, the curators rarely have an opportunity to be more than valued administrators constantly sliding back and forth between various spheres of pressure, negotiating between players and participants that are all very different in their demands and prerogatives (concurrent events, local decision-makers, writers and editors and journalists, artists, and so on). Arguably, if the curators do their job well, they will not do justice to any one of them completely – which might sound like an attempt to put some drama into what is a matter of organisational skills and endless conceptual reshuffling. But it still makes sense, since the crux of cutting-edge practices these days is the attempt to be critical without making anyone irate. This always lets the participants themselves feel better, but perhaps there are other criteria worth aiming for.

Contributors

Hoor Al Qasimi was President and Chief Director of the 7th International Biennial of Sharjah (2005). In 1998, she co-curated 'NEAR' with Derek Ogbourne and Peter Lewis. In 2002, she co-curated 'Andy Warhol' with Brigitte Schenk from the Brigitte Schenk Gallery in Cologne. Both exhibitions were held at the Sharjah Art Museum. In 2003, she was Director of the 6th edition of the Sharjah Biennial, which she co-curated with Peter Lewis. She is currently completing an MA in curating contemporary art at the Royal College of Art, London.

Frederick N. Bohrer teaches art history and archaeology at Hood College in Frederick, Maryland, USA. Author of *Orientalism and Visual Culture: Imagining Mesopotamia in Nineteenth-Century Europe* (2004), he has edited the catalogue and curated the exhibition *Antoin Sevruguin and the Persian Image: Photographs of Iran, 1870–1930*, first shown at the Smithsonian Institution, Washington, DC (1999). He has written widely on both the material and theoretical aspects of the representational interchange between Europe and the Middle East.

Kamal Boullata is an artist and writer. His art may be found in public collections including the Institute of the Arab World, Paris; Khaled Shoman Foundation, Amman; the British Museum, London; Patronato de la Alhambra, Granada; and New York Public Library. His writings have appeared in *Third Text*, *Muslim World*, *Peuples Méditerranéens*, *Journal of Palestine Studies* and in *The Encyclopedia of the Palestinians* (2000, 2005). He is also the author of *Recovery of Place: A Study of Contemporary Palestinian Art* (in Arabic, 2000) and *Palestinian Art: Discontinuities and Resistance*,

1845–2005 (forthcoming). He is co-editor of *If Only the Sea Could Sleep* (with Mirène Ghossein, 2003) and of *We Begin Here: Poems for Palestine and Lebanon* (with Kathy Engel, 2007).

Nicolas Bourriaud is an art critic and curator. He founded the Palais de Tokyo in Paris, which he co-directed until 2006. He is the author of *Relational Aesthetics* (1998) and *Post-Production* (2002), both translated into more than ten languages. He was curator for, among others, the Aperto of the 1993 Venice Biennial and 2005 Lyon Biennal, and was a member of the curatorial team of the 2005 and 2007 Moscow Biennials.

Boris Brollo is the President of the Italian branch of the International Association of Plastic Arts (UNESCO). He has curated shows at the 1997, 1999 and 2001 Venice Biennials and was chief curator of the Italian pavilion at the 2004–2005 Beijing Biennial. Co-author with Giancarlo Politi of *Cosi Lontano, Cosi Vicino* (2000), he has published in *Flash Art*, *Juliet Art Magazine*, *Duemila* and in over thirty catalogues of the exhibitions he has curated.

Jean Fisher teaches art theory at Middlesex University and London's Royal College of Art. She is the editor of *Global Visions: A New Internationalism in the Visual Arts* (1994) and *Reverberations: Tactics of Resistance, Forms of Agency in Trans/cultural Practices* (2000) and has co-edited with Gerardo Mosquera *Over Here: International Perspectives on Art and Culture* (2004). A contributor to the *Documenta 11* catalogue (2002), she is the author of *Vampire in the Text* (2003).

Laymert Garcia dos Santos is Professor of Sociology at the State University of Campinas, São Paolo, Brazil. He currently writes on the relationship of technology to art and culture. His essays have been published in English, French, German, Spanish and Portuguese in *Third Text*, *Parachute*, *Via Regia*, *Zehar*, *Nada* and other periodicals. He is also a frequent contributor to exhibition catalogues. With Cynthia Morrison-Bell, he was co-curator of *Citizens,* an exhibition that toured the United Kingdom in 2005. At present he is developing the concept of an opera on Amazonia, in collaboration with ZKM (Centre for Art and Media), the Goethe Institute and the Munich Biennial of Opera.

Elias Khoury is a novelist, literary critic and dramatist. He is the editor of the literary supplement of Beirut's daily *an-Nahar* and Distinguished Professor of Arabic Literature at New York University. He is the author of four volumes of literary criticism and eleven novels, a number of which have been published in English, French, Hebrew and German translations. His theatrical works have been performed in Beirut, Cairo, Paris, Vienna, Basel, Barcelona, Brussels and Berlin.

Ken Lum was co-curator of the 7th International Biennial of Sharjah (2005). In that year he also co-curated Shanghai Modern: 1919–1945. His artwork represented Canada at the 1995 Sydney Biennial, the 1997 São Paulo Biennial and the 2002 Documenta XI. Lum has realised public art in Vancouver (2001), St Moritz (2004) and Vienna (2006). The co-founder with Zheng Shengtian of the *Yishu Journal of Contemporary Chinese Art* in 2000, he headed the Graduate Program in Studio Art at the University of British Columbia and has taught in other art institutions in Canada, France, Germany, Martinique and China.

Joseph A. Massad teaches modern Arab politics and intellectual history at Columbia University. He is the author of *Colonial Effects: The Making of National Identity in Jordan* (2001), *The Persistence of the Palestinian Question* (2006) and *Desiring Arabs* (2007). He has published in *Critique*, *Social Text*, *Global Dialogue*, *Public Culture*, *Cultural Critique*, *Interventions* and the *Journal of Palestine Studies*.

Khaled Mattawa is a poet and translator. His poetry collections include *Ismailia Eclipse* (1995) and *Zodiac of Echoes* (2003). His poetry has been published in numerous journals including *Poetry*, *The Kenyon Review*, *New England Review* and the *Pushcart Prize* anthology. The translator of three volumes of Arabic poetry, he is the recipient of an Academy of American Poets Award. Currently, he is Professor of English and Creative Writing at California State University, Northridge.

Gerardo Mosquera is art critic and curator at the New Museum of Contemporary Art in New York. A founder of the Havana Biennial, he was also a member of the curatorial team for its 1984, 1986 and 1989 editions,

the 1997 Johannesburg Biennial and the 1996 São Paolo Biennial. Editor of *Beyond the Fantastic: Contemporary Art Criticism from Latin America* (1995), with Jean Fisher he co-edited *Over Here: International Perspectives on Art and Culture* (2004), and with Adrienne Samos *Ciudad Multiple City: Urban Art and Global Cities: an Experiment in Context* (2005). His writings have appeared in a wide range of publications.

Achille Bonito Oliva is curator, art critic and lecturer at La Sapienza University in Rome. His publications in English include *Trans Avant Guarde International* (1998), *The Ideology of the Traitor* (2000) and *Art Tribes* (2002). Curator of many exhibitions that travelled throughout Europe and the USA, including *Marcel Duchamp: 1902–1968* (1973) and *Avant Guarde and Trans Avant Guarde Art: 1968–1977* (1982), he was chief curator of the Italian pavilion in the 1985 Paris Biennial, the 1993 Venice Biennial and the 1998 Dakar Biennial.

Jack Persekian was Head Curator of the 7th International Biennial of Sharjah (2005). He was founding director of Anadiel Gallery and the Al-Ma'mal Foundation of Contemporary Art in Jerusalem. Among the recent exhibitions he has curated are 'New Palestinian Art' at Ifa Galleries in Bonn, Stuttgart and Berlin (2002); 'Disorientation: Contemporary Arab Artists from the Middle East', House of World Culture, Berlin (2003); and 'Reconsidering Palestinian Art', Fundación Antonio Perez, Cuena, Spain (2006). He produced and directed the Millennium Celebrations in Bethlehem (2000), the Geneva Initiative, Public Commitment Event (2003) and the Palestinian Cultural Evening at the World Economic Forum in the Dead Sea, Jordan (2004).

Nadia Tazi is former editor of the Paris-based periodical *Intersignes*. Translations of her work into English include *Mutations* (2001) and the five-volume series *Fragments for a History of the Human Body* (1989, 1990), which she co-edited. She has edited the four-volume series *Keywords*, comprising *Truth, Experience, Gender* and *Identity*. The series was published simultaneously in China, France, Lebanon, Morocco, South Africa and the United States.

Tirdad Zolghadr was co-curator of the 7th International Biennial of Sharjah (2005). Since 2004, he has curated events at Cubitt in London, IASPIS in Stockholm, the Kunsthalle in Geneva, and in various Tehran artspaces. He writes for *Frieze*, and has contributed critical writings to *Parkett*, *Bidoun*, *Cabinet*, *Afterall*, *Neue Zurcher Zeitung* and *Straits Times Singapore*. In 1999, he founded the Tehran-based online publication *Bad Jens*. His recent *Tropical Modernism* was premiered at the 2006 Oberhausen Short Film Festival. He is currently preparing a long-term exhibition and research project addressing social class in the art world, which is scheduled to take place at the Gasworks in London, Platform in Istanbul and Tensta Konsthalle. His novel, *Softcore*, is published by Telegram Books, London.

Bibliography

Abu Lughod, Janet L., *Before European Hegemony: The World System AD 1250–1350*, New York: Oxford University Press, 1989.

Appadarai, Arjun, *Modernity at Large: Cultural Dimensions of Globalization*, Minneapolis: University of Minnesota Press, 1996.

Bailey, David A., and Gilane Tawadros, *Veil: Veiling, Representation and Contemporary Art*, London: inIVA /Modern Art Oxford, 2003.

Basuelo, Carlos, et al., *Diversities: Europe and the Other*, Milan: Charta, 2005.

Berger, John, *The Shape of a Pocket*, London: Bloomsbury, 2001.

Bhabha, Homi K., *The Location of Culture*, London and New York: Routledge, 1994.

Bohrer, Frederick N., *Orientalism and Visual Culture: Imagining Mesopotamia in Nineteenth-Century Europe*, Cambridge: Cambridge University Press, 2004.

Bourriaud, Nicholas, *Relational Aesthetics*, Dijon: Les Presses du réel, 1998.

——*Post-Production. Culture as Screenplay: How Art Reprograms the World*, New York: Lukas & Sternberg, 2002.

Bové, Paul A., ed., *Edward Said and the Work of the Critic, Speaking Truth to Power*, Durham, NC: Duke University Press, 2000.

Cowen, Tyler, *Creative Destruction: How Globalization is Changing the World's Culture*, Princeton: Princeton University Press, 2002.

Crane, Diana, *Global Culture: Media Arts, Policy and Globalization*, London: Routledge, 2002.

Danzker, Jo-Anne Birnie, Ken Lum and Zheng Shengtian, eds., *Shanghai Modern 1919-1945,* Ostfildern: Hatje Cantz, 2005.

Esche, Charles, et al., *Shifting Maps: Artists' Platforms and Strategies*, Rotterdam: Netherlands Architecture Institute, Uitgevers, 2004.

Fisher, Jean, *Global Visions: Towards a New Internationalism in the Visual Arts*, London: Kala Press/inIVA, 1994.

——*Vampire in the Text: Narratives of Contemporary Art*, London: inIVA, 2003.

Garcia Canclini, Néstor, *Hybrid Cultures: Strategies for Entering and Leaving Modernity*, Minneapolis: University of Minnesota Press, 1995.

Gentz, Natascha, and Stefan Kramer, eds, *Globalization, Cultural Identities, and Media Representations*, Albany: State University of New York Press, 2006.

George, Susan, *The Lugano Report: On Preserving Capitalism in the 21st Century*, London: Pluto Press, 1999.

Glissant, Edouard, *Poetics of Relation,* Ann Arbor: University of Michigan Press, 1997.

Hackforth-Jones, J., and M. Roberts, eds., *Edges of Empire: Orientalism and Visual Culture*, Oxford: Blackwell, 2005.

Hopkins, A. G., ed., *Globalisation in World History*, New York: W.W. Norton & Co. 2004.

Hourani, Albert, *A History of the Arab Peoples*, New York: Warner Books Edition, 1991.

Jameson, Frederic, and Masao Miyoshi, eds., *The Culture of Globalization*, Durham, NC: Duke University Press, 1999.

Kapur, Geeta, *When Was Modernism: Essays on Contemporary Cultural Practice in India*, Delhi: Manohar Publishers, 2003.

Knopp, Hans-Georg, and Johannes Odenthal, eds, *Disorientation: Contemporary Arab Artists from the Middle East*, Berlin: The House of World Cultures, 2003.

Kocur, Zoya, and Simon Leung, eds, *Theory in Contemporary Art since 1985*, Oxford: Blackwell, 2004.

McEvilly, Thomas, *Art and Otherness: Crisis in Cultural Identity*, New York: McPherson & Company, 1992.

Menocal, María Rosa, *The Ornament of the World: How Muslims, Jews and Christians Created a Culture of Tolerance in Medieval Spain*, Boston and New York: Little Brown & Co., 2002.

Moore-Gilbert, Bart, *Postcolonial Theory: Contexts, Practices, Politics*, London: Verso, 1997.

Mosquera, Gerardo, ed., *Beyond the Fantastic: Contemporary Art Criticism*

from Latin America, London: inIVA/MIT Press, 1995.

——and Jean Fisher, eds., *Over Here: International Perspectives on Art and Culture*, Cambridge, MA and London: MIT Press, 2004.

——and Adrienne Samos, eds., *Ciudad Multiple City: Urban Art and Global Cities: an Experiment in Context*, Amsterdam: KIT Publishers, 2005.

Nancy, Jean-Luc, *Being Singular Plural*, Palo Alto: Stanford University Press, 2000.

Oliva, Achille Bonito, *The Ideology of the Traitor: Art, Manner and Mannerism*, Milan: Mondadori-Electa, 2000.

——*Art Tribes*, Milan: Skira, 2002.

——*White and Other: In Any Case, Art,* Torino: Umberto Allemandi, 2007.

Papastergiadis, Nikos, ed., *Complex Entanglements. Art, Globalisation and Cultural Difference*, London: Rivers Oram Press, 2003.

——*Spatial Aesthetics: Art, Place and the Everyday*, London: Rivers Oram Press, 2006.

Said, Edward W., *Orientalism*, New York: Vintage Books, 1978.

——*Culture and Imperialism*, New York: Knopf, 1993.

Schaebler, Birgit, and Leif Stenberg, eds., *Globalization and the Muslim World: Culture, Religion and Modernity*, New York: Syracuse University Press, 2004.

Smiers, Joost, *Arts Under Pressure: Promoting Cultural Diversity in the Age of Globalisation*, London: Zed Books, 2003.

Tawadros, Gilane, ed., *Changing States. Contemporary Art and Ideas in an Era of Globalisation*, London: inIVA, 2004.

Tazi, Nadia, ed., *Keywords: Identities: For a Different Kind of Globalization*, New York: Other Press, 2004.

——ed., *Keywords: Nature*, New York: Other Press, 2005.

Vanderlinden, Barbara, and Elena Filipovic, eds., *The Manifesta Decade: Debates on Contemporary Art Exhibitions and Biennials in Post-Wall Europe*, Cambridge, MA: MIT Press, 2006.

Wagstaff, Sheena, and Edward W. Said, *Mona Hatoum: The Entire World as a Foreign Land*, London: Tate Gallery Publishing, 2000.

Zolghadr, Tirdad, Charlotte Bydler, and Michaela Kehrer, *Ethnic Marketing*, Zurich: JRP Ringier, 2007.

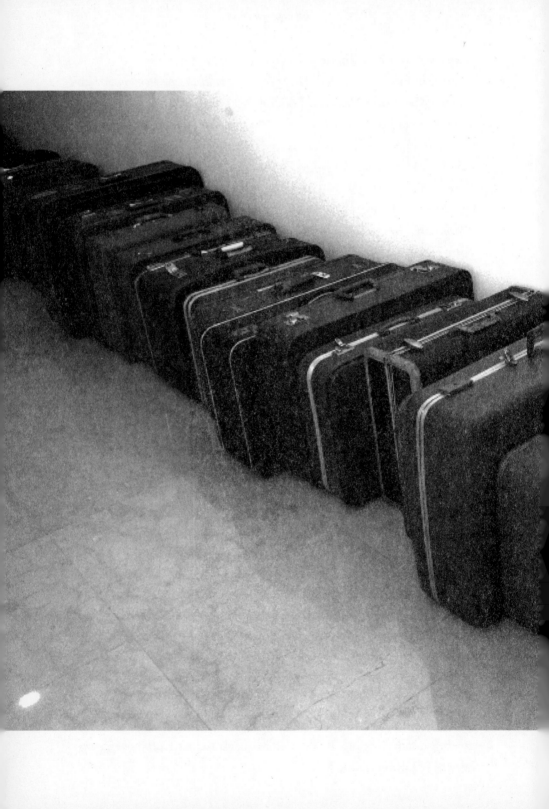

Zoe Leonard, 2003
1961
43 vintage suitcases
9.15 m x 55.9 cm x 73.7 cm